MIMESIS
INTERNATIONAL

C000046084

ITALIAN FRAME
n. 3

directed by Andrea Minuz (Sapienza Università di Roma) and Christian Uva (Università Roma Tre)

REQUIEM FOR A NATION

Religion and Politics in Post War Italian Cinema

Edited by
Roberto Cavallini

MIMESIS
INTERNATIONAL

© 2016 – Mimesis International
www.mimesisinternational.com
e-mail: info@mimesisinternational.com
Book series: *Italian Frame*, n. 3
isbn 9788869770562
© MIM Edizioni Srl
P.I. C.F. 02419370305

TABLE OF CONTENTS

ANCIENT RITUALS, MODERN MYTHS

TO MY NATION

PIER PAOLO PASOLINI

Not an Arab people, not a Balkan people, not an ancient people
but a living nation, but a European nation:
and what are you? Land of babes, hungry, corrupt
governors employed by landowners, reactionary prefects,
small lawyers smeared with grease and with dirty feet,
liberal functionaries carcasses like bigoted uncles,
a barrack, a seminary, a free beach, a whorehouse!
Millions of petit bourgeois as millions of pigs feed gouging
under the unharmed villas,
among colonial houses peeling now like churches.
Exactly because you have existed, now you do not exist,
exactly because you were conscious, you are unconscious.
And only because you are Catholic, you cannot think
that your evil is all evil: the blame of every evil.
Sink to the bottom of this beautiful sea of yours, clear the world.

Pier Paolo Pasolini, *La religione del mio tempo*, 1961 (as translated
in: Roberta L. Payne, *A Selection of Modern Italian Poetry in Translation*, McGill-Queen's University Press, 2004).

ROBERTO CAVALLINI

INTRODUCTION

This volume was conceived, as the title suggests, as a ritual for a deceased entity: a requiem for a nation, Italy, which, for the first time in its history and against any foreseen prefigurations, entered modernity through an idiosyncratic process of overlapping religious and political powers. In particular, this anthology grew out of the need to investigate the intricate relationship between religion and politics in post war Italian Cinema and to examine how their convergence configures the contradictions of Italy's cultural history. As various scholars contend, the interdependence of religion and politics in world history and society didn't end with modernity and the Italian case study proves exactly this point. On the contrary, it grew stronger with unexpected global ramifications, urging renewed analysis and configurations of the socio-political conditions that affect our global understanding of religion. The so-called process of desecularization illustrated by Peter L. Berger maintains that modernization didn't trigger the decline of religion as an institution; on the contrary, it "provoked powerful movements of counter-secularization".[1] Following Berger and other scholars' insights, the current debate on the 'post-secular society', term popularized by Jurgen Habermas in recent years and employed by other scholars,[2] reflects on the challenges

1 Peter L. Berger, "The Desecularization of the World: A Global Overview" in Peter L. Berger (ed.), *The Desecularization of the World: Resurgent Religion and World Politics* (Gran Rapids, MI: Wm. B. Eerdmans Publishing Co., 1999), p. 3.

2 See Jurgen Habermas, *Secularism's Crisis of Faith: Notes on Post-Secular Society*, in «New perspectives quarterly», Vol. 25 (2008), pp. 17-29; among others, see the following anthologies: Philip S. Gorski, David Kim Kyuman, John Torpey, Jonathan Vanantwerpen (eds.), *The Post-secular in Question: Religion in Contemporary Society* (New York: New York University

and implications that religious practices impose globally to notions of citizenship and cultural difference. The conceptualization of a post-secular society points, according to Habermas, to 'a change of consciousness' in relation to the fact that secularism is an outdated framework of analysis to understand the global impact of religion on the contexts of international politics.[3]

In Italy, the correlation between sovereignty, the Vatican and the State's catholicity and the consequential identification between State and the idea of a Catholic Nation, coincided with the Lateran Treaty between Italy and the Vatican, signed respectively by Benito Mussolini and cardinal secretary of state Pietro Gasparri on February 11, 1929. The nexus between Nation and Catholic Religion is perfectly described in the Vatican's newspaper *L'Avvenire d'Italia* published on March 2, 1929: "The religious predicament, with all its interferences, at this point penetrates the structure and the organization of the Nation, which is now a Catholic State, seat of the Roman Pontificate, guarantee of its sovereignty".[4] The historical transition, which for the first time proclaimed and defined the dissemination of Catholic religion nationally both in legal and symbolic terms, took place primarily during the 1930s. It is worth observing how it aptly corresponded with the plan of the Catholic Roman Church to actively participate in the emerging field of mass media both in terms of distribution and production: in the specific context of cinema, for example, by 1935, more than 1600 parish cinemas were established nationally and in 1939 the Centro

Press, 2012); Rosi Braidotti, Bolette Blaagaard, Tobijn de Graauw, and Eva Midden (eds), *Transformations of Religion and the Public Sphere: Postsecular Publics* (New York: Palgrave MacMillan, 2014). For an investigation on the relationship between faith and secularism through the concept of fanaticism, please see Alberto Toscano, *Fanaticism: On the Uses of an Idea* (London: Verso, 2010).

3 See Luca Mavelli and Fabio Petito (eds.), *Towards a Postsecular International Politics: New Forms of Community, Identity, and Power* (New York: Palgrave MacMillan, 2014).

4 "Il problema religioso con tutte le sue inferenze penetra ormai la struttura e le connettiture della Nazione, ch'è ora uno Stato cattolico sede del Romano Pontificato, garante della sua sovranità", reported in Francesco Traniello, "L'Italia cattolica nell'era fascista" in Gabriele De Rosa, Tullio Gregory, André Vauchez (eds.), *Storia dell'Italia religiosa, Epoca contemporanea* (Bari: Laterza, 1995), p. 275.

Cattolico Cinematografico (Catholic Cinematographic Centre, or CCC) was founded.[5] The project to create a Catholic Nation was conceived as a totalizing mission in order to implement several direct interventions in order to instruct, transmit and inculcate onto the Italians an official Catholic way of life. Moreover, as Manlio Graziano points out in a recent study evocatively titled 'The Catholic Century', the Catholic Church's subtle geopolitical strategy to disseminate and propagate its influence should be identified in the moment of its advanced crisis; in order to adapt itself to the dynamics of the contemporary world, the Vatican Council II, which took place between 1962 and 1965, was organized.[6]

This volume, while not engaging directly with the theories and practices delineated by recent studies on the post-secular, posits itself within the trajectories acknowledged by this new mindset. Starting from the assumption that to conduct a reflection on Italian post-war cinema one must investigate the inevitable impact of Catholic religion on everyday life and its social, political and cultural dimensions, the objective of this volume is to offer a critical framework to understand religion's influence on different levels of the Italian political and cultural landscapes. In the last ten years, there has been an exponential growth of studies on the relationship between religion and film, both in the international academic literature[7] and in the context of Italian film industry.[8] However, a comprehensive study of religion as the principal motif of investigation in Italian post-war cinema

5 See Francesco Traniello, "L'Italia cattolica nell'era fascista", p. 290.
6 Manlio Graziano, *Il Secolo Cattolico: la strategia geopolitica della Chiesa* (Bari: Laterza, 2010).
7 See, among others: S. Brent Plate, *Religion and Film: Cinema and the Re-creation of the World* (New York: Wallflower Press, 2007); Jolyon P. Mitchell, S. Brent Plate (eds.), *The Religion and Film Reader* (New York: Routledge, 2007); John Lyden (ed.), *The Routledge Companion to Religion and Film* (London: Taylor & Francis, 2009); William L. Blizek (ed.), *The Bloomsbury Companion to Religion and Film* (London: Bloomsbury Publishing, 2013); Daniel Biltereyst and Daniela Treveri Gennari (eds.), *Moralizing Cinema: Film, Catholicism, and Power* (New York: Routledge, 2015).
8 Daniela Treveri Gennari, *Post-War Italian Cinema: American Intervention, Vatican Interests* (New York: Routledge, 2009). In Italian, see the four volumes edited by Ruggero Eugeni, Dario E. Viganò (eds.), *Attraverso lo schermo. Cinema e cultura cattolica in Italia* (Rome: EdS Edizioni, 2006).

through a multidisciplinary methodological perspective is still lacking in English-language academic film studies literature. This edited anthology, in its narrow scope, thus seeks to fill this gap and to examine how religion was lived, performed, criticized and represented in the film productions of the era, rethinking its importance in underscoring the tensions and challenges occurring in Italy at the time.

<p style="text-align:center">***</p>

This volume approaches the relationship between religion and politics in Italian post-war cinema through four general sections: 'Propaganda and censorship'; 'Framing belief: Pasolini and Petri'; 'Religion in Italian Popular Cinema'; 'Ancient rituals, modern myths'. Each section includes two chapters that employ quite distinctive academic and thematic approaches to the subject matter. The first section of the anthology addresses issues of propaganda and censorship providing innovative research perspectives based on the recent investigation of Italian archives. Tomaso Subini's contribution inaugurates the anthology with a critical reflection on *Pastor Angelicus*, the first film production of the Catholic Cinematographic Centre (CCC); the ways in which, during and after the end of World War II, various political actors influenced and appropriated the film for different purposes, transforms the film into an emblematic example of the intrusion of the Catholic Church into the Italian political arena. Subini's research is based on an extensive archival investigation and it is part of a broader project dedicated to the study of the role of Italian cinema in the negotiation processes of religious and social conflicts in Italy between the 1940s and the 1970s. In the second contribution of this first section, Daniela Treveri Gennari and Silvia Dibeltulo provide a striking examination of the just recently accessible archives of the left-wing newspaper *L'Unità* in order to configure the conditions through which parish cinemas in Rome were organized and functioned in relation to censorship and commercial issues. Focusing on archival documents referring to the year 1959, the chapter analyzes the dynamics at play between the censorial system created by the CCC and the not

always deferential attitude conducted by local exhibitors to run a profitable, Italian style business.

The second section focuses on how two unique auterial voices such as Pier Paolo Pasolini and Elio Petri engaged with the notion of belief from two opposite, yet complementary, ways. Laura Rascaroli argues about Pasolini's contradictory affective use of sublimity through an exploration of his immanent portrait of Jesus in *Il Vangelo secondo Matteo* (*The Gospel According to St. Matthew*, 1964). Rascaroli, following Deleuze's questioning, reads Pasolini's filmic sublime as the attempt to configure a belief thorn from faith and given back to rigorous thought. Fabio Vighi's essay instead examines, in the heart of the Italian process of modernization, the new religion of capitalism dissected by Elio Petri and how his films portray the alienating capitalist relations imposed on our subjectivities. Elio Petri's films, in Vighi's words, show the complex relationship between the notion of belief and the capitalist world; they become political films "insofar as they delve into the abyssal, ultimately ontological crisis of the subject".

Religion in Italian Popular Cinema is the general framework of the third section of this volume. My own contribution explores Pietro Germi's 'socio-comedy of manners' through the experience of religion in post-war Italy and its portrayal of Italian stereotypes with a shift from religion as a culture of externality (*Divorzio all'Italiana*) to religion as a political form of power (*Signori e Signore*). In the second contribution of the section, Fernando Gabriel Pagnoni Berns & Juan Ignacio Juvé configure an analysis of the religious gender repression in Southern Italy emerging from popular films such as the horror film *Il Demonio* (The devil, Brunello Rondi, 1963), and the rural giallo *Non si sevizia un paperino* (Don't torture a duckling, Lucio Fulci, 1972), both shot in rural areas between Puglia and Basilicata.

The final section of the volume investigates the notion of the end through different approaches: Roberto Chiesi examines the documentary and ethnographic form through the work of seminal authors and filmmakers still quite unknown outside of Italy such as, among others, Cecilia Mangini, Luigi di Gianni and Gian Vittorio Baldi. Their atypical ethnographic films look into the archaic funereal rituals of a popular Italy and the communities' relation with death, away from the official procedures of the Catholic

Church, topic studied and investigated also by anthropologist and historian of religions Ernesto De Martino. Daniele Rugo's essay finally closes the volume offering an engaging analysis of how different authors (from Sciascia to Ferreri, from Rosi to Comenicini) reflected on the idea of the apocalypse; the political and cultural atmosphere of Italian society in the 1970s was nearing its end, with on the background the malfunctioning of the State epitomized by the power structure created and managed by the Democrazia Cristiana (Christian Democracy Party).

This volume does not seek to delineate a comprehensive and systematic investigation of how religious and political powers are intertwined in the post-war Italian context. Instead, what it tries to convey is a combination of several perspectives to rethink the Italian cultural landscape through the prism of religion in cinema. If the post-secular dimension asks for the recalibration of our understanding of religion in a global perspective, the primary objective of this book is to expose the reader to the implications and several levels of signification of cinema's peculiar engagement with aesthetic, social and political dynamics and its negotiation of religious and political issues.

PROPAGANDA
AND CENSORSHIP

TOMASO SUBINI

PASTOR ANGELICUS AS A POLITICAL TEXT

After the First Vatican Council in 1868, which stated Papal infallibility, the figure of the Pope assumed increasing importance within the Catholic Church, generating in some cases a genuine devotion. Nevertheless, during the last century (and even more so now) such devotion has run the risk of bordering on idolatry. I am here referring to that particular idolatry which in the modern mass media system is dedicated to the so called "media icons", for example to movie stars and popular television characters. John Paul II has provided remarkable examples of what it means to be a "live broadcasted Pope", having a camera filming him even in the moment of his death. The roots of this phenomenon can be traced back to Pius XII's pontificate, first of all for the obvious reason that the media system generating media icons became full-blown precisely when he was pontiff, extending its influence into every sphere of public life; secondarily, because Pius XII became immediately aware of the potential of mass media to spread his image, his words and his teachings. Pius XII's considerable media exposure probably reached its climax with the film *Pastor Angelicus*, which in this essay I intend to analyse as a political text. The research that I carried out in several Catholic archives[1]

1 This research is part of a broader project dedicated to the study of the role of Italian cinema in the negotiation processes of religious and social conflicts in Italy between the 1940s and the 1970s. The project draws on the tradition of studies (well developed in Italy) on the Church and the Catholic movement in relation to processes of modernization. More specifically, the project studies if, how and when the Church used modern means of communication (and in particular cinema, at the centre of the media system in the period) with the aim of carving out a space for itself in the complex dynamics of a modern mass society. The goal of the research is to retrieve data in order to reconstruct the profile of institutions and

has given me the opportunity to shed new light on the close connection between *Pastor Angelicus* and the Vatican's political goals. I will show how the Vatican used this film politically in two different periods: on its first release and, five years later, on the election campaign for the first republican parliament.

Pastor Angelicus *and Fascism*

Towards the end of the Thirties, in the wake of the encyclical titled *Vigilanti cura*, Catholics became increasingly active in the field of cinema. Their activity, however, bears witness to the mixed feelings that they harboured towards cinema: on the one hand, they feared it for its great influence on people's perceptions; on the other hand, they tried to gain control of the new medium to "yield it for specific pastoral stances".[2] The Catholic Cinematographic Centre's (henceforth: CCC) productions, inaugurated in 1942 with *Pastor Angelicus*, responded to the latter need. Ideated to celebrate the twenty-fifth anniversary of Pius XII's ordination as bishop, the film narrates the pope's life using found-footage drawn from several sources (Luce Institute, News on the March, older shootings by the same CCC) edited together with new sequences shot on location in the Vatican by CCC's cameramen following Pius XII's activities for several months, showing the pope at work in his office, during his daily walk or having his audiences.

people involved, and thus a first outline of the relations between Catholic Church and cinema in Italy. Data are being collected following two main strands: archival research and the study of newspapers and magazines. The collected data are stored into a database, in order to foster dialogue between the group of researchers (from University of Milan) directly involved in data collection and scholars helping to interpret the data. To improve the research, a work-in-progress web site (http://users.unimi. it/cattoliciecinema/) has been created, featuring the main topics of the project. The website also presents the frameworks that are supposed to coordinate research. The principal aim of the website, however, is to make documents available: all documents have been tagged and can be queried accordingly.

2 Dario Viganò, *Il progetto cattolico sul cinema: i pionieri*, in Raffaele De Berti (a cura di), *Un secolo di cinema a Milano* (Milan: Il Castoro, 1996), p. 139.

According to the main scholarship on the topic, the film's director is Romolo Marcellini. However, the head of the entire production was Luigi Gedda, President of the CCC and future President of the Catholic Action,[3] an association established by Pius X in 1905 to provide a framework for the organization of Catholic laity. The activities of the Catholic Action were supposed to provide a spiritual support but they actually reached far beyond their scope, since both Pius XI and Pius XII thought of the association's members as ground troops who would re-Christianize Italian society, and this – as David Kartzer has sarcastically observed – "would require much more than simple prayers".[4] During the Forties and Fifties, Gedda's Catholic Action first contributed to the electoral victory of Christian Democrats and subsequently, by means of its 'oceanic' meetings, gave Pius XII the illusion that a re-foundation of Christian society was already possible. It is not surprising, therefore, that the first film through which Gedda intended to launch Italian Catholics in the arena of film production should be first and foremost a political text. The definition of *Pastor Angelicus* as 'political' relies on the meaning that Catholics gave to this word. As Luigi Civardi (the Ecclesiastical Consultant of the CCC) explains in his presentation of the film on the pages of the CCC magazine, the film was conceived first of all as an instrument of apostolate and propaganda:

> Produced by a centre established by the Ecclesiastical Authority, *Pastor Angelicus* is a genuine expression of the Catholic apostolate in the field of cinema. In fact, this film is an action of apostolate, an instrument of Catholic propaganda. As such it should be considered by all priests and believers, especially those engaged in the Catholic Action.[5]

3 On Gedda see Ernesto Preziosi (ed.), *Luigi Gedda nella storia della Chiesa e del Paese* (Rome: Ave, 2013).

4 David Kartzer, *The Pope and Mussolini. The Secret History of Pius XI and the Rise of Fascism in Europe* (Oxford: Oxford University Press, 2014), p. 56.

5 "Il *Pastor Angelicus* fu realizzato da un ente che, istituito dalla Autorità Ecclesiastica, è espressione autentica dell'apostolato cattolico nel campo cinematografico. In realtà questo film è un'opera di apostolato; un mezzo di propaganda cattolica. Come tale lo devono considerare i Sacerdoti e i fedeli tutti, e specialmente coloro che militano nell'Azione Cattolica"

The political nature of *Pastor Angelicus* is particularly evident if the film is contextualized in its own times, characterized as they were by rapid political changes. The ability to respond adaptively to such changes accounts for the film's political purpose. As Gedda writes in a letter dated 1944, the film production started in December 1941, on the occasion of Pacelli's episcopate jubilee. It is worth mentioning that Gedda, in the same letter, defines himself as the sole «responsible» for the production.[6] Few months earlier, the German invasion of the Soviet Union had been launched by three army contingents directed by the same commanders guiding the 1940 invasion of France. The German army believed that within three to six months of their invasion, the Soviet regime would collapse from lack of domestic support. In that case, Great Britain would certainly have accepted Hitler's peace offer, rejected after the fall of France; the war would have ended, and Hitler and Mussolini would have been the governors of Europe.

The cover of the 1942 July issue of the magazine «Cinema», directed by Mussolini's son, Vittorio, featured a frame of the film under production representing the Pope. The issue also contained a presentation of *Pastor Angelicus* from the point of view of the Fascist regime. After stressing that Pius XII is Italian, the article describes the film as "an apotheosis that unites Rome and the Pope, signifying the greatness of the eternal Rome at whose foundation is grafted the miracle life of Christ who is Roman".[7] "Christ is Roman" was "a catchy little formula", coming from a well-known verse of Dante,[8] employed often at that time "to explain the providential mission assigned to the city of the Caesars and the Popes, and now continued by Fascism".[9] For the

(Luigi Civardi, *Il Pastor Angelicus e i cattolici*, «Rivista del Cinematografo», a. XVI, n. 3, 1943, pp. 27-28).

6 Luigi Gedda, letter to Urbano Cioccetti, 15 settembre 1944, Isacem, Fondo Presidenza Generale, series XV, file 3, folder 1.

7 "Un'apoteosi che accomuna Roma e il Papa, significazione della grandezza di Roma eterna alle cui origini si innesta la miracolosa vita di Cristo che è romano" (L., *Pastor Angelicus*, «Cinema», n. 145, July 10, 1942, p. 359).

8 "Quella Roma onde Cristo è romano" (*Purgatorio*, XXXII, 102).

9 "Un'orecchiabile formuletta [...] per spiegare la provvidenziale missione assegnata alla città dei cesari e dei papi, raccolta ora dal fascismo" (Lucia

Fascist regime, therefore, Pius XII, before being the Pope, was an eminent Italian as Jesus was a Roman citizen; as a consequence and quite expectedly, the movie review appraised *Pastor Angelicus* as a Fascist film. No surprise, then, that an image of the Pope among soldiers was chosen among the photographs accompanying the article. The presentation on Vittorio Mussolini's magazine can be read as the first attempt made by the Fascist regime to appropriate the film. Perhaps it was also for this reason that Pius XII ordered the issue of the magazine to be withdrawn from all Roman newsstands, as revealed by an informative note written on July 16, 1942 by an employee of the Ministry of Popular Culture:

> The latest issue of "Cinema", dated July 10, features a large portrait of the Pope on its cover, where usually photographs of the "stars" appear, since the magazine (p. 359) deals with *Pastor Angelicus*. It seems that in recent days the Holy See has entrusted some delegates with purchasing at the various Capital's newsstands all the issues of the magazine, in order to withdraw it from circulation.[10]

A year later, Italy experienced one of the worst moments in its recent history. This was firstly due to Mussolini's fall; secondly, to the proclamation of the Armistice with the Anglo-Americans; thirdly, to the military occupation by Germans troops on Italian soil; and finally, to the escape of King Vittorio Emanuele III, the government and the army's generals. The consequence of this brief but intense sequence of events was a widespread sense of abandonment: soldiers felt abandoned by their officers, all Italians felt neglected by those authorities who should have

Ceci, *L'interesse superiore. Il Vaticano e l'Italia di Mussolini* [Rome-Bari: Laterza, 2013], p. 171).

10 "L'ultimo numero di 'Cinema', in data 10 luglio, ha pubblicato nella co-pertina, dove di solito appaiono fotografie delle 'dive' dello schermo, un grande ritratto del Papa, dato che nell'interno (pag. 359) la rivista si occupa del film *Pastor Angelicus*. Risulta che la Santa Sede ha in questi giorni inviato dei propri incaricati ad acquistare presso le varie edicole della Capitale tutti i numeri della rivista, allo scopo di ritirarla dalla circo-lazione" (in Archivio Giulio Andreotti at the Archivio Storico dell'Istituto Luigi Sturzo di Roma, Serie Cinema, folder *Clero e cinema: polemiche sulla censura*, file 1072).

been protecting them. Only the Resistance groups (and in particular the communist ones) and the Pope took advantage of this political and institutional void. In fact, these two forces, the Communists and the Catholics, would compete for the political power in the immediate aftermath of the war. For these reasons it can be argued that *Pastor Angelicus* played a key role to spread a positive image of the Pope in a very crucial moment.

Yet, *Pastor Angelicus* is not an anti-Fascist film, for a simple reason indicated, among others, by Gianni Baget-Bozzo: "Christian anti-Fascism was a widespread position among Catholics, but it was not a position of the Church".[11] Rather, *Pastor Angelicus* is a film that gradually became autonomous, freeing itself from Fascist control. However, the Pope started his campaign as guide of an exit strategy from the crisis in the very moment in which he asserted an autonomous presence in the institutional void created by the collapse of the State. It should be pointed out that the film was a work in progress continuously modified to be adapted to rapidly changing political landscape. The CCC had been filming the most significant events that happened in the Vatican since the late Thirties. For the first time, *Pastor Angelicus* gave concrete expression to a finished media product, in line with the Vatican's political goals and communication ambitions of that period.[12]

Let's consider the period during which the film is produced: the production of the film took one year, from December 1941 to December 1942. Whilst the initial project, illustrated and described in an archival document titled *Premise*, was very cautious in order to avoid disappointment amongst the Fascist regime and strived to achieve a balance between the intentions of the Catholic and the Fascist propaganda, the final product seemed to present Pius XII as an alternative to Mussolini. Even better, it presented the peace

11 "L'antifascismo cristiano fu una concezione diffusa tra i cattolici, ma non fu una posizione della Chiesa" (Gianni Baget-Bozzo, *Il partito cristiano al potere. La DC di De Gasperi e di Dossetti 1945-1954* [Florence: Vallecchi, 1974], p. 52). On relationship between Church and Fascism see David Kertzer.

12 The idea of establishing a permanent production activity would, from then on, never ceased and years later, in 1983, John Paul II, realizing its importance, institutionalized it with the foundation of the Vatican Television Centre. See Dario Viganò (ed.), *Telecamere su San Pietro. I trent'anni del Centro Televisivo Vaticano* (Milan: Vita e Pensiero, 2013).

advocated by Pius XII and the war proposed by Mussolini as mutually exclusive. Promoting such a view when the Axis began to lose the war was unacceptable for the Fascist regime, which withdrew the film from Italian distribution.[13] The gap between the project's initial aspirations and its actual reception should be understood in the changed context in which its production developed. Mostly a year passed between the design and the distribution of the film. During this period, Mussolini's war had proved far from easy to win and it seemed as if Italy would probably lose it. Elena Agarossi explains:

> The Italian defeats in Africa and Russia in the second half of 1942 [...], especially the one at El Alamein, led to a series of timid attempts by the Italians to make contact with the Allied forces [...] to sound out Allied intentions regarding an eventual separate peace.[14]

As early as December 4, 1942 (few days before the release of *Pastor Angelicus*), the German ambassador in Rome had to deliver the following threatening statement: "A separate peace aimed at keeping the war away from the Italian mainland would automatically make it a theatre of war".[15] During the 1942 fall, the course of the Second World War in the Mediterranean basin had suffered an irreversible turn in favour of the Allied Powers. As Claudio Pavone underlined, in all countries occupied by the German army (in France and Yugoslavia, for example),

> the resistance got truly under way only towards the end of 1942, when Stalingrad, the Anglo-American landing in French North Africa, and El Alamein showed, for those with eyes to see, the turn the military tide had unequivocally taken.[16]

13 See Luigi Freddi, *Il cinema* (Rome: L'Arnia, 1949); new edition *Il cinema. Il governo dell'immagine* (Rome: Centro Sperimentale di Cinematografia / Gremese, 1994), pp. 371-372.

14 Elena Agarossi, *Una nazione allo sbando* (Bologna: il Mulino, 1993); second enlarged edition 1998; English expanded edition *A Nation Collapses. The Italian Surrender of September 1943* (Cambridge: Cambridge University Press, 2000), pp. 32-33.

15 Baron von Mackensen, in F.W. Deakin, *The Brutal Friendship* (London: Weidenfeld & Nicolson, 1962), p. 145. Quoted in Claudio Pavone, *Guerra civile* (Turin: Bollati Boringhieri, 1991); translated as *A Civil War. A History of the Italian Resistance* (London/New York: Verso, 2014), p. 9.

16 Claudio Pavone, p. 51.

We do not know precisely what information the Vatican intelligence had about the development of war. It is likely that the Vatican, at the end of 1942, could not foresee the oncoming total collapse of the Fascist State. However, what we can say with a fair degree of certainty is that the Pope (as the other heads of state) was already fully aware of the growing difficulties that the Axis armies were facing. It might be also because of "the increasingly widespread realization that Italy was on its way to catastrophe"[17] that the film was changed.

The stated purpose of the original project was to convey Rome as much as the Pope: "As the background of the [film's] first half is Rome [*Urbe*], as the background for the second half [...] can be represented by the Vatican".[18] Originally the film was clearly divided into two parts: the first one was supposed to be dedicated to the State and the second one to the Church, in perfect Concordat-style. It is difficult to assert whether Gedda was aware that his film was pursuing goals which were contrary to the Fascist regime and consequently simulated a concordance of interests that never existed; it might be possible, however, that he realized later, when the production was already underway, that Catholics could have exploited the film to pursue new objectives, in accordance of the new political context delineated by the war crisis.

The film, in Gedda's perception, ran the risk to be blocked by the Fascist censorship. In a document, written after having obtained the censorship visa and entitled *Report around the film Pastor Angelicus*, Gedda confessed that he was "worried about difficulties of [...] political nature".[19] Perhaps he was worried because the film was no more what it was supposed to be. Anyway, in the same document we come to know that the film has been seen by Minister Alessandro Pavolini and by the Director of Cinematographic Central Office Eitel Monaco, "who wanted to

17 Elena Agarossi, p. 33.
18 "Come lo sfondo artistico del primo tempo è costituito dall'Urbe così lo sfondo del secondo tempo [...] può essere rappresentato dalla Città del Vaticano" (*Premessa*, Isacem, Fondo Presidenza Generale, series XV, file 2, folder 6).
19 "Preoccupavano le difficoltà di indole [...] politica" (Luigi Gedda, *Relazione intorno al film Pastor Angelicus*, 1942, Isacem, Fondo Presidenza Generale, series XV, file 2, folder 6).

personally replace the ordinary censorship board",[20] and that after "very few and minor changes"[21] requested by the Minister, the film was allowed to enter the final stage of production in order to be released in December with its regular censorship visa. Nevertheless, few days later, Pavolini realized that he had underestimated the danger of the film and ordered its removal, as witnessed for example by the American Jesuit Vincent McCormick who sharply described life in wartime Rome on his diary: "Here in Rome it [the film] only ran for a few days, and was ordered off the screen by the civil authorities. The Pope became too popular, it is said: it led to demands for peace".[22]

Pastor Angelicus *and Communism*

Another factor to ponder when considering *Pastor Angelicus* as a political text, is its function during the electoral campaign in the early months of 1948, which saw the democratic front of Communists and Socialists opposed to the Catholics led by Alcide De Gasperi. With the aim of supporting the electoral propaganda, Gedda deployed four trucks equipped with film projectors, speakers and microphones and sent them to Southern Italy. Each truck was operated by a technician, who was responsible for screening the film, and by a trained propagandist, whose task was to deliver, at the end of each projection, a suitable lecture. In the three months preceding the 1948 election, the trucks visited nearly 130 areas,[23] mostly

20 "I quali vollero personalmente sostituirsi all'ordinaria commissione di censura" (Luigi Gedda, *Relazione intorno al film Pastor Angelicus*, 1942, Isacem, Fondo Presidenza Generale, series XV, file 2, folder 6).

21 "Pochissime e leggere modifiche" (Luigi Gedda, *Relazione intorno al film Pastor Angelicus*, 1942, Isacem, Fondo Presidenza Generale, series XV, file 2, folder 6).

22 James Hennessey, *American Jesuit in Wartime Rome. The Diary of Vincent A. MacCormick, SJ*, «Mid America», n. 56, 1974; cit. in John Pollard, *The Papacy in the Age of Totalitarianism. 1914-1958* (Oxford: Oxford University Press, 2014), p. 353.

23 For a complete list cfr. Mario Casella, *18 aprile 1948. La mobilitazione delle organizzazioni cattoliche*, (Galatina: Congedo, 1992), pp. 213-230.

within the southern region called Lucania. An updated version
of *Pastor Angelicus* was screened in every village.

Lucania was known as one of the poorest regions of Italy. It is
difficult to understand what it meant to live in this area in the
post-war period. One's propagandist report affirms:

> I have found great misery in many villages: barefoot children
> walking on the snow in full winter [...]. From time to time I entered
> the homes of poor people and was amazed to see how they live in
> houses with no toilets, all packed in one room where you eat and
> sleep in the most terrible promiscuity.[24]

During those years, Catholics were not the only group interested
in Lucania's social and political situation. The publication, in 1945,
of the novel *Christ Stopped at Eboli* by communist writer Carlo Levi,
very well-received in Italy and abroad, provoked a swift reaction on
southern Italy's issues which regain interest and attention in the
cultural and social agenda. Eboli, a small town near Salerno, was at
that time considered the farthest bastion of civilization, where the
road and the railway terminated. Accessing the area beyond that
point, one could reach Lucania, a desolate land forgotten by God.
Christ, and all that the word 'Christ' meant in terms of civilization
for the Catholics, had never set its foot there.

The success of *Christ Stopped at Eboli* urged many left-wing
intellectuals to visit Southern Italy, with the aim to personally
experience the condition of poverty in which half of the Italian
population was living. Among them, we find the communist
anthropologist Ernesto De Martino who guided some famous
ethnographic expeditions. Few years later, following the teachings
of Levi and De Martino, Pier Paolo Pasolini decided to set part
of his *Gospel according to St. Matthew* in Lucania. In this sense,

24 "Ho trovato in molti paesi grande miseria: bambini scalzi nel pieno
 inverno camminare sulla neve [...]. Sono entrato qualche volta nelle
 case della povera gente e sono rimasto meravigliato nel vedere in che
 modo vivono in quelle povere case senza nessuna comodità igienica
 e tutti riuniti in una sola stanza dove si mangia e si dorme nella più
 impressionante promiscuità" (Accursio Ajassa, Bartolo Paschetta,
 Giovanni Cavina, Oliviero Menchi, *Relazione sulla attività di propaganda
 svolta attraverso carrozzoni cinematografici nel mezzogiorno*, January-April
 1948, Isacem, Fondo Presidenza Generale, series VI, file 54).

Lucania was a symbol, the symbol of that poverty which post-war Italy could not ignore. From this point of view, Lucania was also a political symbol, which both Communists and Catholics wanted to appropriate for themselves. With its four trucks, Gedda's Catholic Action wanted to respond to the challenge raised by Levi's book.

In those years, Communists and Catholics surprisingly produced similar narrations on Lucania. Gedda's propagandists described an episode that might well be read along with the best pages of *Sud e magia*, one of De Martino's best-known studies, on the persistence of magical beliefs in the southern Italy. The screening of *Pastor Angelicus* in Montalto Uffugo, a small village in the province of Cosenza, led to

> a case that stunned everyone. While a Communist militant walked around among the crowd filling the huge square [...] telling his followers not to give any sign of disapproval, the Secretary of the Communist Section, less clever than his colleague, when the majestic figure of the Holy Father appeared and was welcomed by a thunderous ovation, pronounced indecent words to one of his close companions and made a vulgar gesture, which was witnessed by the common people with indignation. When he arrived home he felt an acute pain in his groin and his right hand was suddenly paralyzed. He has not been able to vote, and doctors fear that they will not be able to save him, since they suspect him to have cancer. We are trying to save his soul, at least.[25]

The tone used in the propagandists' reports bears witness to the crucial importance of cinema for their own purposes: "This

25　"Un caso che ha sbalordito tutti. Mentre un Attivista Comunista andava in giro fra la folla che gremiva l'immensa piazza [...] dicendo ai suoi seguaci di non dare nessun segno di riprovazione, il Segretario della Sezione Comunista invece, meno furbo del primo, quando apparve la maestosa figura del S. Padre, fra gli applausi più fragorosi, disse delle parole indecenti ad un suo vicino compagno e fece un gesto poco bello notato dai buoni con indignazione. Appena tornato a casa lo sorprende un dolere acutissimo all'inguine e gli si assecca la mano destra. Non ha potuto votare ed i medici disperano di salvarlo perché pare si tratti di un cancro. Stiamo cercando di salvargli almeno l'anima" (Gaetano Mauro, letter to the General ACI President, April 23,1948, Isacem, Fondo Presidenza Generale, series VI, file 54).

form of propaganda has proved exceptionally effective".[26] The trucks sometimes ventured "in villages where people had never or almost never seen a car, much less a cinema. The reception by the population has been extraordinary and vibrant. As soon as the truck reached a village, crowds of people came swarming around it".[27]

Another propagandist provides us with his daily schedule:

> In every village, every morning I held meetings with Catholic Action's members, talking very clearly about the obligation to vote and illustrating the guidelines of the Holy Father. [...] The film screening was always held either in the afternoon or in the evening, awaited by people, be them on our side or not.[28]

The final remark is crucial: while only Catholic Action's members attended the conference, the screenings were attended by all villagers, even by non-Catholic people.

Screenings usually took place in the evening, in the main square. The lecture was held between the first and the second half of the film, following a practice used in those very same years by another important propagandist, the Belgian Dominican Félix Morlion. It is worth spending a few words on the figure of

26 "Questa forma di propaganda si presenta di una efficacia veramente eccezionale" (Accursio Ajassa, Bartolo Paschetta, Giovanni Cavina, Oliviero Menchi, *Relazione sulla attività di propaganda svolta attraverso carrozzoni cinematografici nel mezzogiorno,* Janury-April 1948, Isacem, Fondo Presidenza Generale, series VI, file 54).

27 "In paesi dove mai o quasi mai avevano veduto un'automobile e tanto meno il cinema. Da parte della popolazione le accoglienze sono entusiaste, vibranti. Il popolo accorre in massa attorno alla macchina al nostro arrivo nei vari paesi" (Accursio Ajassa, Bartolo Paschetta, Giovanni Cavina, Oliviero Menchi, *Relazione sulla attività di propaganda svolta attraverso carrozzoni cinematografici nel mezzogiorno,* Janury-April 1948, Isacem, Fondo Presidenza Generale, series VI, file 54).

28 "In ogni paese durante la mattinata tenevo le adunanze ai soci di AC parlando molto chiaro riguardo all'obbligo del voto e illustrando loro le direttive del Santo Padre. [...] La proiezione cinematografica si svolgeva sempre il pomeriggio o la sera, attesa da tutti, nostri o non nostri" (Accursio Ajassa, Bartolo Paschetta, Giovanni Cavina, Oliviero Menchi, *Relazione sulla attività di propaganda svolta attraverso carrozzoni cinematografici nel mezzogiorno,* January-April 1948, Isacem, Fondo Presidenza Generale, series VI, file 54).

Morlion, whose activity is closely related to the topic of this essay. Morlion arrived in Italy from the USA in 1944. He travelled with the support of the American Office of Strategic Services (OSS), the forerunner of the Central Intelligence Agency (CIA). He had the reputation of being an expert in psychological war and propaganda techniques. The following year, he founded the International University of Social Studies Pro Deo, which soon became "the reference point for the ideological collaboration between the Vatican and the American government against the influence of communism in Italy".[29] In the aftermath of the war, the Italian Communist Party obtained a large following among workers and peasants.[30] Although the party members were mainly belonging to the lower classes, its Secretary Palmiro Togliatti also sought to reach out to the middle class. In its attempt to penetrate society in all its areas, the Italian Communist Party came into conflict with the Church. The extraordinary growth of the Italian Communist Party alarmed even the Americans, who considered Italy as their strategic base in Europe for fighting the Cold War and would not allow the country to be under the influence of the Soviet Union. Morlion developed a method of his own to use cinema for propaganda, named 'cineforum', which he also theorized. The format, based on the "presentation-discussion" formula, is explained by Morlion with the following words: a cineforum presents

> a great film after which our ideas gain a more concrete intensity thanks to discussions and explanations. No (communist) branch chief can prevent his comrades from watching a free screening.

29 "Il punto di riferimento per la nascente collaborazione ideologica contro l'influenza del comunismo in Italia tra il Vaticano e le diramazioni del governo Americano" (Ennio Di Nolfo, "La storia del dopoguerra italiano e il cinema neorealista: intersezioni", in *Il neorealismo tra cinema e storia, tra cultura e politica*, duplicated proceedings of a convention held in Turin, November 16-17, 1989, p. 20).

30 "In the mid-1943 the PCI had a membership of approximately 5.000. During 1944 it expanded to 502.000. By the fifth congress of the party in December 1945 this figure reached 1.771.000" (Stephen Gundle, *Between Hollywood and Moscow* [Durham and London: Duke University Press, 2000], p. 23; originally published as *I comunisti italiani tra Hollywood e Mosca: la sfida della cultura di massa, 1943-1991* [Florence: Giunti, 1995]).

Announcing the screening of a surprise film at the end, the public is essentially trapped by curiosity between the two films.[31]

Already a weapon against Fascism, *Pastor Angelicus* thus became one against Communism during the post-war years. The public, cornered between the two halves of the film, was reminded by propagandists about "the priority of the moment: to work for the triumph of the Church, to be loyal to the Pope, to work for the Pope, bearing in mind the importance of the battle that awaits us in April".[32]

According to propagandists' reports, the screening of *Pastor Angelicus* aroused enthusiastic reactions:

It was moving to hear the thunderous applause when the white figure of the Pope appeared on the screen. Sometimes men with communist lapel badge carefully followed, with tears in their eyes, the day of the Pope as it was shown on the screen.[33]

31 "Un grande film all'inizio, dopo il quale, sotto forma di discussione e di spiegazioni, le nostre idee acquistano una più grande intensità concreta tra gli spettatori […]. Nessun capocellula riesce ad impedire ai compagni di assistere ad una proiezione cinematografica gratuita. Essendosi annunciato che un film a sorpresa sarà proiettato alla fine, la gente è praticamente imprigionata dalla curiosità tra i due film" (Félix Morlion, *Conclusioni su un'azione decisiva per ridurre l'influenza comunista in Italia*, 1950, archive of the Provincia Romana di S. Caterina da Siena OP, at the Basilica di Santa Maria Sopra Minerva, Roma, PR.B.II.8.14).

32 "L'imperativo del momento: lavorare per il trionfo della Chiesa, essere fedeli al Papa, lavorare per il Papa, tenendo ben presente la importanza della battaglia che ci attende in aprile" (Accursio Ajassa, Bartolo Paschetta, Giovanni Cavina, Oliviero Menchi, *Relazione sulla attività di propaganda svolta attraverso carrozzoni cinematografici nel mezzogiorno*, January-April 1948, Isacem, Fondo Presidenza Generale, series VI, file 54).

33 "Era commovente sentire gli applausi scroscianti quando sullo schermo appariva la bianca figura del Papa. Erano alcune volte uomini col distintivo comunista all'occhiello che con le lagrime agli occhi seguivano attentamente la giornata del Papa com'era rappresentata sullo schermo" (Accursio Ajassa, Bartolo Paschetta, Giovanni Cavina, Oliviero Menchi, *Relazione sulla attività di propaganda svolta attraverso carrozzoni cinematografici nel mezzogiorno*, January-April 1948, Isacem, Fondo Presidenza Generale, series VI, file 54).

Pastor Angelicus was named by the public "the cinema of the Pope"[34] and the chance to see it was welcomed as "a gift from the Pope".[35] In short, the widespread perception was that the Pope personally sent his film as a gift to the poor people of the South. The propagandists describe some "moving episodes"[36] which help us understand how the film spread the Vatican's propaganda:

> At Senise (Potenza) the evening after the screening of the film a speaker from the Popular Democratic Front held a rally in the square spewing forth insults against the Church, the Pope and the priests. At the end of the rally, a young peasant climbed on the stage where the communist speaker had been, took his arm and told him breathlessly in his dialect: "You're an idler because you are going around to deceive us poor people, who don't know how to respond, but here we have a 'movie professor' who knows well what should be said and in the meantime I want to tell you that what you told us is not true: we saw the Pope last night and we heard how much charity he does all over the world".[37]

34 "Il cinema del Papa" (cfr., ad esempio, Rocco Pellettieri, letter to Giuseppe Lazzati, March 10, 1948, Isacem, Fondo Presidenza Generale, series VI, file 54).

35 "Un regalo del Papa" (Accursio Ajassa, Bartolo Paschetta, Giovanni Cavina, Oliviero Menchi, *Relazione sulla attività di propaganda svolta attraverso carrozzoni cinematografici nel mezzogiorno*, January-April 1948, Isacem, Fondo Presidenza Generale, series VI, file 54).

36 "Episodi commoventi" (Accursio Ajassa, Bartolo Paschetta, Giovanni Cavina, Oliviero Menchi, *Relazione sulla attività di propaganda svolta attraverso carrozzoni cinematografici nel mezzogiorno*, January-April 1948, Isacem, Fondo Presidenza Generale, series VI, file 54).

37 "A Senise (Potenza) la sera dopo la rappresentazione del film un oratore del Fronte Democratico Popolare ha tenuto nella piazza un comizio vomitando ingiurie contro la Chiesa, il Papa e i sacerdoti. Terminato il comizio un giovane contadino sale immediatamente sul balcone dove parlava l'oratore comunista e prendendolo per un braccio gli dice animatamente nel suo dialetto: 'Sei un vagabondo perché vai in giro ad ingannare noi povera gente che non sappiamo risponderti, ma c'è qui il professore del cinema che saprà risponderti ed intanto io ti dico che non è vero quello che tu ci hai detto perché il Papa l'abbiamo veduto ieri sera e abbiamo sentito quanta carità fa in tutto il mondo'" (Accursio Ajassa, Bartolo Paschetta, Giovanni Cavina, Oliviero Menchi, *Relazione sulla attività di propaganda svolta attraverso carrozzoni cinematografici nel mezzogiorno* January-April 1948, Isacem, Fondo Presidenza Generale, series VI, file 54).

At Chiaramonte I had to screen the film until three in the morning because the crowd did not want to move out of the room, they kept saying: "It's the first time we see the movie, the Pope has made this gift to us, why do you want to send us away so soon?".[38] The young people from Verzino, a village without electricity, reached me by climbing to Savelli in order to see *Pastor Angelicus* and there they spent the night standing around a brazier with a few litres of wine I offered them. In order to test them, I asked why they made such a great sacrifice on a cold and stormy night only to see *Pastor Angelicus*, and they told me: "You can often see the Pope in flesh, we have never seen him, we may well make this sacrifice to see him at least on screen".[39]

Conclusions

The analysis of the documents concerning *Pastor Angelicus* preserved at the Catholic Action's archive provides an image that is far more complex than the one offered by the literature on the subject, starting from Carlo Falconi's 1954 article, where the author states that "with *Pastor Angelicus* prof. Gedda and the Catholic Centre [...] tried to substitute the Duce's myth with the rising icon of the pontiff".[40] Such interpretation has been

38 "A Chiaramonte dovetti proiettare fino alle tre di notte non volendo la
 folla a nessun costo sgombrare la sala perché diceva: 'È la prima volta
 che vediamo il cinema, è stato il Papa a farci questo regalo perché volete
 mandarci via così presto?'" (Accursio Ajassa, Bartolo Paschetta, Giovanni
 Cavina, Oliviero Menchi, *Relazione sulla attività di propaganda svolta
 attraverso carrozzoni cinematografici nel mezzogiorno*, January-April 1948,
 Isacem, Fondo Presidenza Generale, series VI, file 54).
39 "I giovani di Verzino paese della Sila sprovvisto di luce elettrica sono
 saliti da me a Savelli (m. 1070) per poter vedere il *Pastor Angelicus* ed
 ivi hanno poi passato la notte in piedi attorno a un braciere con pochi
 litri di vino da me offerti, avendo io chiesto, per provarli, come mai per
 vedere il *Pastor Angelicus* avessero fatto così grande sacrificio di una notte
 fredda e di bufera, mi fu risposto: 'Voi il Papa lo vedete in carne ed ossa
 spesso, noi non l'abbiamo mai visto, possiamo ben fare questo sacrificio
 per vederlo almeno in cinema'" (Accursio Ajassa, Bartolo Paschetta,
 Giovanni Cavina, Oliviero Menchi, *Relazione sulla attività di propaganda
 svolta attraverso carrozzoni cinematografici nel mezzogiorno*, January-April
 1948, Isacem, Fondo Presidenza Generale, series VI, file 54).
40 "Con *Pastor Angelicus* il prof. Gedda e il Centro Cattolico [...] tentarono

endorsed by both Gian Piero Brunetta in his *Storia del cinema italiano*,[41] and by Mino Argentieri in his influential study on Italian cinema during the World War II,[42] and, in more recent times, by Federico Ruozzi.[43]

Yet, the political nature of the film did not only aim to free the Church from fascism, but it also achieved other goals that arose at different moments and to which it proved remarkably pliant. Archival documents (in particular the film's treatment: *Premessa*, Isacem, Fondo Presidenza Generale, series XV, file 2, folder 6) illuminate an aspect that has frequently been overlooked: the original idea of the movie was in perfect Concordat style. Therefore, it may not seem paradoxical that the film could have, at the beginning, even facilitated the relationship with Fascism[44] (although the original project shared only a part of the regime's propagandistic aims), while later on it began to pursue new and initially unforeseen goals when it became evident that the Fascist regime would no more be part of the political landscape in the aftermath of the war. In very much the same way, once the collaboration between different anti-fascist forces was no more a necessity, and with the 1948 elections (which were already ruled

di sostituire al mito del duce quello sorgente del pontefice" Carlo Falconi, *Battono il mea culpa sul petto degli altri*, «Cinema Nuovo», a. III, n. 45, October 25, 1954, p. 250. Falconi further developed his position in la *Chiesa e le organizzazioni cattoliche in Italia (1945-1955)* (Turin: Einaudi, 1956).

41 Gian Piero Brunetta, *Storia del cinema italiano*, second edition in four volumes containing two older studies (issued respectively 1979 and in 1982) (Rome: Editori Riuniti, 1993).

42 Mino Argentieri, *Il cinema in guerra. Arte, comunicazione e propaganda in Italia 1940-1944* (Rome: Editori Riuniti, 1998).

43 Federico Ruozzi, *Pius XII as Actor and Subject. On the Representation of the Pope in Cinema during the 1940s and 1950s*, in Daniel Biltoreyst, Daniela Treveri Gennari, *Moralizing Cinema. Film, Catholicism and Power* (New York: Routledge, 2015), pp. 158-172. Gianluca della Maggiore adopts a different perspective, presenting the film as "one of the most mature outcomes" of the "cinematographic embrace between the Church and fascism", as a "constant and overt collaboration at almost all stages of the film's production [...] when there were only faint hints that events would turn in favour of the Allies" (*La Chiesa e il cinema nell'Italia fascista. Riconquiste cattoliche, progetti totalitari, prospettive globali (1922-1945)*, PhD dissertation in Storia e scienze filosofico-sociali, Università degli Studi di Roma "Tor Vergata", XXVII ciclo, p. 315).

44 Gianluca della Maggiore, pp. 104-117.

by Cold War logic) approaching, the film began serving new political aims, this time with an anti-communist function. *Pastor Angelicus*'s remarkable pliancy to different political goals finds further confirmation in its 'open text' form, changing through time by having sequences added or removed according to the needs of the moment.[45]

45 A thorough and detailed study of the film's textual variants has not been produced yet.

Daniela Treveri Gennari and Silvia Dibeltulo

CENSORSHIP *ITALIAN STYLE*
Catholic policies and programming in 1950s Roman parish cinemas

Catholic film policies in 1950s Italy were clearly dictated by the Censorship Commission of the Centro Cattolico di Cinematografia[1] (Catholic Cinema Centre), which issued regular guidelines about what films were acceptable by the Vatican and, therefore, allowed to be screened in religious venues. If, in theory, the network of parish cinemas was meant to function as an indirect way to censor immoral film content, the reality, however, was very different. In practice, films that the CCC considered unsuitable to be screened in parish venues were often shown in religious cinemas. So far – as information on parish cinema programming is patchy and inconsistent – no research has been conducted which looks at the extent to which the Catholic Church's attempt to moralise programming in parish cinemas was successful. This chapter will use Rome as a significant example of contrast between official policies and programming practices in the city which was the centre of the Catholic world, housing the Vatican, the Catholic curia and all the main Catholic administration offices. Catholic programming of the Roman parish cinemas listed in the online archive of the local edition of the newspaper *L'Unità* will be analysed. A research into what religious venues screened will offer a better understanding of the dynamics at play between the educational and censorial intentions of parish cinema networks in the mind of the ecclesiastic establishment and the actual processes put in place by the local exhibitors to attract audiences and run a profitable business.

1 From now on CCC. The CCC was established in 1935 with the intention of exercising a 'moral control over films to be screened in public and religious venues' (Elena Mosconi, *L'impressione del film: contributi per una storia culturale del cinema italiano, 1895-1945*, [Milan: Vita e Pensiero, 2006], p. 266).

The role of parish cinemas and their exhibition practice in 1950s Rome

Film exhibition in 1950s Rome was characterized by a wide range of cinema theatres (first, second and third run cinemas) which offered audiences an extensive selection and a rapid turnover of films.[2] In this broad exhibition network were also included parish cinemas, which represented a significant proportion of venues available in the city (58 cinemas compared to 130 commercial ones[3]), as well as having a wide geographical distribution not only in the centre, but also in the outskirts, where 'the choice of commercial venues was more limited'.[4] Official ecclesiastic documents commenting on the role of parish cinemas clearly emphasised the educational and moral connotation of these institutions. In a passage from the encyclical *Miranda Prorsus* (1957), Catholic cinema halls were not only 'subject to ecclesiastical authority' but they also had to be carefully monitored in order to 'observe faithfully and exactly the rules laid down in these matters'.[5] The encyclical seems to express the need to cautiously supervise a wide network of cinemas which – while under close local and regional scrutiny – would at times still infringe the protocols imposed by the CCC.

These protocols dictated that films, programmed to be shown in parish cinemas, had to be prudently chosen according to the classification of the CCC. As the *Lettera Pontificia Commissione per la Cinematografia* (1st June 1953, n. 246) reminded Catholics,

> films to be shown in parish cinemas can only be selected amongst the ones declared [to be suitable] for all by the CCC, and exceptionally

2 For further information on film exhibition in 1950s Rome, see Daniela Treveri Gennari and John Sedgwick, 'Memories in context: the social and economic function of cinema in 1950s Rome', *Film History*, 27 (2015), n. 2, pp. 76-104.

3 These figures are taken from both the ACEC database and the SIAE list of cinemas (1957-1958).

4 Daniela Treveri Gennari, 'Moralizing Cinema while Attracting Audiences: Catholic Film Exhibition in Post-War Rome', in *Moralizing cinema: Film Catholicism and Power*, ed. by Daniel Biltereyst and Daniela Treveri Gennari (New York: Routlege, 2014), p. 275.

5 http://w2.vatican.va/content/pius-xii/en/encyclicals/documents/ hf_p-xii_enc_08091957_miranda-prorsus.html#Nota%2038 (accessed 28 August 2015).

for adults, with appropriate changes. In no case parish cinemas are allowed to show films judged by the CCC as for adults with reservation, not recommended and excluded.[6]

The function of the CCC guidelines is often explained in the Catholic press as a way to safeguard Christian morality and protect vulnerable audiences from inappropriate films. The lack of morality in films was not an issue with which the Catholic Church had to deal only in the post-war years: several articles published before this period on the *Rivista del Cinematografo* (the main Catholic cinema magazine in Italy) had often raised the issue of the Church's problematic approach towards cinema.[7] Nonetheless, the post-war period represents a moment in which the moralising function of cinema is further put under threat. This era saw both a wide increase in the number of parish cinemas opening across the country (which made it harder to exercise the same control as in the pre-war years), and the growingly common practice of handing over the responsibility of parish cinemas to a lay person, who was often more interested in the commercial aspect of the exhibition than in its moral one. The latter issue, in fact, is at times pointed out by the ecclesiastic authorities, when exhorting the Catholic cinema circuit to respect the guidelines provided by the CCC.[8]

The fact that controversial articles published in *La Rivista del inematografo* accused parish venues of being commercial enterprises like any other, especially when it came to film programming choices, indicates that the distinct role of parish cinemas was not so clearly demarcated. In *Lo Stato cinematografaro*, Ernesto Rossi alleged that parish cinemas showed films of all genres, were often run by non-religious people, but still took advantage of governmental legislation

6 Lettera della Pontifica Commissione per la Cinematografia (1st June 1953), n. 246 in Marco Bongioanni, *Cinema, caso di coscienza* (Asti: Libreria Dottrina Cristiana, 1962), p. 26.

7 On the 20th of May 1938, for instance, Giuseppe De Mori asks the readers whether censorship is needed to control the immorality of films and concludes affirming that the concept of morality cannot change with the changes in times and that morality does not have an age, being 'an eternal law which comes from God's law' (Giuseppe De Mori, 'Il cinema e i criteri di censura', *La Rivista del Cinematografo*, Year XI, n. 5, 20th May 1938, p. 107).

8 Francesco Dalla Zuanna, 'A.C.E.C.: Anno dieci', *La Rivista del Cinematografo*, Year XXXII, September-October 1959, Supplement to n. 9-10, p. 11.

when they applied for an exhibition licence in areas already overpopulated by commercial cinemas.[9] This caused commercial exhibitors to feel financially discriminated and accuse the Catholic cinema network of benefitting from administrative facilitations.[10]

Methodology

By carrying out an in-depth analysis of parish cinemas programming, our research aims at uncovering the complexities and inconsistencies inherent in the Catholic Church's censorship strategy and operations. Programming data available in the online listings of the Rome edition of the Italian newspaper *L'Unità* has been collected for the last four months of 1959. The year 1959 was selected for a number of reasons. From the 10th of September 1959 all Roman editions of the main national newspapers introduced a specific section for parish cinemas programming. Prior to this, religious venues were included, without distinction, in the section dedicated to third run cinemas. This is a significant change in terms of formally acknowledging parish cinemas as a distinct sector of the film exhibition network.

9 Enrico Rossi, *Lo Stato cinematografaro* (Florence: Parenti Editore, 1960), p. 124.
10 Aldo Bernardi (representative of the small exhibitors for the area of Milan), in a letter published in 1955 by the *Bollettino dello spettacolo* (the National Exhibitors Association's trade journal) accuses parish cinemas of on one side not respecting the CCC guidelines, while on the other taking advantage of governmental financial privileges. His industrial point of view is important here, as it shows how the ambiguous behaviour of parish cinemas is negatively perceived by the commercial sector that was keen to re-establish a clear distinction between parish and commercial cinemas (Aldo Bernardi 'Sull'attività dei cinema cattolici', *Bollettino dello spettacolo*, 3 Feb 1955, Year XI, n. 223, p. 5). This lack of distinction between parish and commercial venues is indicated in another letter sent to the editor of the *Bollettino dello spettacolo* and published in the 'Gazzettino delle Grane' (Troubles Newsletter), in which a priest from Varese denounces the dichotomy between parish cinemas, which were described as more and more luxurious and with better technical equipment, and a programming limitation which is restrictive in terms of programming days, publicity and ticket prices ('Il Gazzettino delle grane', *Bollettino dello spettacolo*, 10 November 1954, Year X, n. 214, p. 1).

The year 1959 was also the 10th anniversary of ACEC, the National Association of Catholic Exhibitors.[11] This is a crucial moment, as observed in the special issue of *La Rivista del Cinematografo* dedicated to the event. The magazine, in fact, reflects on the ten years of activities of the organization and on what parish cinemas had represented in Italy at that time: aspects such as the development of the parish cinema network, the importance of the coordinating role of ACEC and SAS (Cinemas Support Service), the fruitful collaboration with AGIS (the National Exhibitors Association), SIAE (the Italian Society of Authors and Publishers), and – on the international front – with OCIC (International Catholic Organization for Cinema), were all discussed.[12] This formal moment of awareness and reflection over the contribution of the Catholic exhibition sector is, therefore, a significant time in order to establish to what extent parish cinemas had really echoed certain Catholic principles.

In the programming analysis of the months September-December 1959, 734 titles were identified and their classification was surveyed in the CCC guidelines. Although the majority of films examined were first released in Italy in the 1950s, some of them date back to the 1940s and 1930s, and even the 1910s (e.g. Charles Chaplin's *Burlesque on Carmen*, 1915). Out of 734, 32 titles were not present in the CCC files and for 174 there was no "moral judgement"[13] available. Therefore, our sample totals 528 films. Our analysis intends to compare what in theory the CCC considered suitable and unsuitable to be screened in parish venues, and what took place in the programming practice. This process is not always straightforward. For example, our examination of the CCC files spans three decades of classification, which creates a significant complication, as their format and regulations changed throughout the years. From 1934 to 1940, in fact, there were three main categories – 'for all', 'for adults', and 'excluded'; from 1941 to 1950 'for adults with reservation' was added; in 1951 a new category, 'not recommended', was included. In 1959, as often reminded both in the religious and the lay press, the

11 ACEC (Associazione Cattolica Esercenti Cinema) was established on the 18th May 1949 in Rome with the intention of coordinating the parish cinema network.

12 Dalla Zuanna, pp. 9-12.

13 Moral judgements focussed on films' ethical aspects, thus explaining for what type of audiences they would be suitable.

only films that were allowed to be screened in parish cinemas were: 'for all' and 'for adults (the latter only with the explicit consensus of the local ecclesiastic authority and the approval of the Censorship Commission of the CCC).[14] In the next section, we will provide an analysis of the programming data to allow a better understanding of the dichotomy between moral and commercial tensions.

Data analysis

The guidelines followed by the CCC to determine film suitability are clearly referenced in both Papal encyclicals (the 1936 *Vigilanti Cura* and 1957 *Miranda Prorsus*) and they categorized films as: positive (for all and for all with reservations), suitable for "experienced" people (for adults and for adults with reservations), and morally dangerous or totally negative (not recommended and excluded). This, however, did not ensure that all Catholics would follow the guidelines, as it emerges from the continuous reminders in the Catholic press of the individual responsibility of making an informed decision when choosing a film to watch. For instance, on the 21st of March 1961, a document announced at the Italian Episcopal Conference the day before, was collectively published in the Catholic press to remind readers of their moral responsibility to follow the CCC guidelines. In his book *Cinema, caso di coscienza*, Marco Bongioanni reflects on this moral responsibility affirming that it is not just a pastoral exhortation, but also a real serious obligation for all Catholics. In fact, while Catholic exhibitors were legally bound to follow the CCC guidelines, Catholic audiences – although not statutory obliged to obey them – still needed to respect them solemnly.[15]

While often the onus is on the individual Catholic, who had to be 'conscious of their duties and responsibilities in relation to contemporary film production' and had to inform 'themselves of the moral judgements issued on films' and comply 'with them with their behaviour', the guiding role of the CCC classification was

14 For a detailed description of the CCC guidelines, see Mons. Luigi Civardi, 'Criteri di valutazione morale dei film', *La Rivista del Cinematografo*, 1940, pp. 178-80.

15 Marco Bongioanni, *Cinema, caso di coscienza* (Asti: Libreria Dottrina Cristiana, 1962), pp. 24, 29.

paramount.[16] This is also manifest in the attention given by some production companies, which would advertise on the Catholic press those films which had been approved by the CCC [FIG. 1 Films presented by the Lux production company and rated for all by the CCC, *La Rivista del Cinematografo*, Year XV, n. 4, 1942]. In 1950 Monsignor Albino Galletto (Ecclesiastic Consultant of the CCC) while accusing cinema of not being Christian mainly because of the lack of Catholic presence in film production, suggested that the only way to influence production was through public opinion, boycotting immoral films and guiding Catholic audiences through the CCC guidelines, and through the parish cinema programming which could 'influence production [...] to give cinema a moral content'.[17] This was once again confirmed by Mons. Francesco Dalla Zuanna (President of ACEC) in an article on *La Rivista del Cinematografo* a few years later, when he assessed the Catholic exhibition's role in encouraging a more moral film production, defining the parish cinemas as an active subsidiary instrument of the apostolate and of the pastoral preaching.[18]

However, film production throughout the 1950s did not seem to respond to the pressure from the CCC guidelines, and the parish cinema circuit did not have a vast selection to choose from when it

16 This is an extract of a letter by the Pro-Secretary of State Mons. Montini to the President of OCIC published in 'Esortazione del Sommo Pontefice sulla classificazione morale dei film', *Lo Spettacolo*, Year 54, Vol. IV, n. 4, Oct-Dec 1954, p. 47. This concept is echoed by Monsignor Albino Galletto in *La Rivista del Cinematografo* two years later, when he emphasises the duty of the Catholic audience to be informed on the CCC guidelines and their power to influence film production by condemning immoral films and encouraging an improvement of what is available in films, both in aesthetic and moral terms. In the same article Galletto confirms the important role played by the CCC when advising producers before starting to make a new film (Albino Galletto, 'L'ufficio permanente nazionale di revisione', *La Rivista del Cinematografo*, Year XXIX, n. 6-7, June-July 1956, p. 10).

17 Albino Galletto, 'I giudizi morali sui film', *La Rivista del Cinematografo*, Year XXIII, n. 2, February 1950, p. 5.

18 Mons. Francesco Dalla Zuanna, 'L'esercizio cattolico', *La Rivista del Cinematografo*, n. 6, 1956, p. 27. This was already clearly stated in an article authored by the Catholic documentarist and theorist Antonio Covi in 1941, in which Catholic cinema was defined 'apostolic cinema', 'a tool that faith can use for the spiritual elevation of the masses' (Antonio Covi, 'Nostro cinema', *La Rivista del Cinematografo*, Year XIV, n. 6, 20th June 1941, pp. 84-85).

came to films deemed to be fit for Catholics. For example, in the year analysed in this chapter, 1959, 528 films were classified: 27 (5.11%) were 'for all'; 12 (2.27%) were 'for all with reservation'; 172 (32.58%) were 'for adults'; 152 (28.79%) were 'for adults with reservation'; 93 (17.61%) were 'not recommended'; and 72 (13.64%) were 'excluded'.[19] Therefore, the films not allowed to be screened in parish cinemas (for adult with reservation, not recommended, excluded) represented 60% of the total amount, leaving a vacuum in the choice of films to be shown. For our analysis, though, it is important to remember that parish cinema programming did not only include films released in that year, but several older films, perhaps to compensate for the lack of suitable works which had just come out. This was a common practice adopted by parish cinemas in order to tackle the problem of not being able to get hold of recent films (often too expensive for Catholic exhibitors) but, predominantly, a way to avoid films morally unsuitable. In fact, if Catholic exhibitors wanted to expand their programming beyond the Sunday screening, they would struggle to find an appropriate selection of films.[20]

From our examination of the categories of films shown in the period taken under investigation (September-December 1959) in relation to the dichotomy between CCC rating and parish cinema programming practices, the following has emerged:

1. The category of 'excluded' includes one film: Lewis Milestone's *No minor vices* (1948), which appears five times in the programming schedule between September and November 1959.

2. The category 'for adults' has the largest number of films (360). This is not an issue *per se*, as these films were allowed in parish cinemas. However, 72 films in this category are defined as 'for adults' in public venues in the moral judgement of the classification files. The 'public venue' definition is also used in other categories, such as 'for all'. Up until 1954, CCC classification had an explicit distinction between films allowed to be screened either in commercial cinemas or in parish cinemas (giving films for commercial cinemas a more lenient rating). After 1954, this distinction disappeared from the

19 *Guida Cinematografica* (Rome: Centro Cattolico Cinematografico, 1963), p. LXIII.
20 Albino Galletto, 'Diritti e doveri delle sale cattoliche', *La Rivista del Cinematografo*, Year XXIII, n. 1, January 1950, pp. 3-4.

classification, but at times was still present in the moral judgments. This suggests that the 72 films in question were not supposed to be shown in parish venues.[21] Moreover, one film (Marino Girolami's *Amore e Sangue*, 1951) – despite being in this category – is defined as morally censurable, which seems to correspond, although implicitly, to the rating 'excluded'.

3. The category 'for adults with reservation', which was clearly not permitted in parish cinemas, presents 7 films[22] in the programming under scrutiny.

4. The remaining films are classified as: 'for all' (122) and 'for all with reservation' (38 films). However, out of the 122 in the 'for all' category, 44 films are defined as 'for all in public venues'. This raises the same issue discussed in relation to the 'for adults in public venues', indicating once again that films unsuitable for parish cinemas were found in their programming.

The total number of films unsuitable for parish cinemas that were, nevertheless, present in their programming is 124 out of the 528 scrutinised for this research. This shows a clear transgression of the CCC guidelines perpetrated by parish cinemas in Rome at that time. This transgression seems, however, to confirm a practice spread more widely across the country in terms of cinema programming, which was often reported both in the Catholic press and in the exhibitors' trade journals. In fact, archival data confirms that Catholic exhibitors were often reminded not only to respect the CCC guidelines, but, for instance, to rent films directly through the dioceses film board in order to avoid wrongdoing.[23] These attempts at monitoring film rental and programming practices to ensure a stricter observance of the rules were often unsuccessful and forced local and national Catholic authorities to take action. In 1956, for example, a joint effort by ACEC and AGIS took place: the presidents

21 This is also made explicit by eight more films across all categories for which the moral judgement state that, with some changes, they could even be shown in parish cinemas.

22 Alessandro Blasetti's *Fabiola* (1949), Wesley Ruggles' *Cimarron* (1931), Alfred Hitchcock's *The Trouble with Harry* (1955), George Sherman's *The Hard Man* (1957), Paul Landres' *Last of the Badmen* (1957), Julio Bracho's *La posésion* (1950), Sidney Salkow's *Jack McCall Desperado* (1953).

23 M. Laccisaglia, 'Sale parrocchiali: concorrenza a fin di bene', *Bollettino dello spettacolo*, 31 January1952, Year VIII, n. 138, p. 3; 'Sanzioni contro cinema parrocchiali', *Bollettino dello spettacolo*, 31 March 1952, YearVIII, n. 142, p. 2.

of both organizations requested local authorities to identify specific cases of disrespect and to report them to their national offices.[24] And yet, what this programming analysis demonstrates is that three years later the problem was still present and Catholic exhibitors were still able to infringe the supposedly tight regulations of the CCC.

When looking specifically at the categories in which the violation took place, some general considerations must be put forth. Some transgressions are obviously more serious than others. When reflecting on the category 'for adults with reservation', Bongioanni states that when the film is considered to be negative (as in the case of 'excluded', 'not recommended' and 'for adults with reservation') it is inherently dangerous as the reservation is related to content in its entirety and not just in isolated scenes.[25] This is evident in the case of the only excluded film found in the programming, Milestone's *No minor vices*. In this film, the sacrament of marriage is disrespected when an artist intrudes into the conservative lifestyle of a successful dentist and his attractive wife, in an attempt to seduce her. Not surprisingly, the film is judged by the CCC in this way:

> the nefarious activity of the eccentric genius stranger that jeopardizes the stability of married life, putting human feelings through a cynical and merciless analysis, gives the film a mark of morbid immorality. Despite the forced moralizing ending, the film is negative.[26]

In spite of this unmistakably adverse judgment, the film appears in the programming not only for five days in three months, but also in several parish venues across the city.

A comparison between the category 'for adults with reservation' with the ones 'for adults' and 'for adults in public venue' reveals some overlaps in terms of content. In fact, all these categories present several of the themes identified by Livio Fantina as highly problematic for the Catholic Church: sexuality, violence and murder, revealing costumes, world of show business, unclear Catholic morality or immoral behaviour, sympathetic portrayal of

24 'Una rigorosa indagine sulla disciplina dei parrocchiali', *Bollettino dello spettacolo*, 14 January 1956, Year XII, n. 272, p. 4.
25 Bongioanni, p. 41.
26 CCC moral judgement available in the *Dizionario del Cinema* issued by the Commissione Nazionale Valutazione Film (CD-rom).

the evil, adultery and extramarital relationships, representation of other religions and ideas against Catholic principles.[27] While in some cases the higher degree of immorality of certain themes explains the negative rating, in several others where the rating is more lenient, the negative aspects of the films appear to be as serious. For instance, the CCC judgement rates the film *Last of the Badmen* (Paul Landres, 1957) as for adults with reservation because of the 'several violent scenes and illegal activities', despite the fact that 'the film ends with the re-establishment of justice'.[28] This is very similar to many of the 'for adults' moral judgments, such as Ray Taylor's *The Son of Billy the Kid* (1949),[29] or Charles Marquis Warren's *Arrowhead* (1953).[30] The extreme example of this ambiguity is presented in the case of Marino Girolami's *Amore e Sangue* (1951), a film which was rated for adults but whose CCC judgement presents numerous similarities with the excluded category:[31] the film is, in fact, described as full of negative elements, such as presenting criminals in a favourable light, despising authority, murders, revenge, defamation, sensual behaviours, and nudity.

In the case of 'in public venue' (which included both the for all and for adults categories), as Monsignor Luigi Civardi (leader of the Catholic Action) reminded the readers of *La Rivista del Cinematografo* in 1940, the films associated with this definition were still unsuitable for parish cinemas, where a more 'religiously and morally selected audience' was present.[32] Therefore, even if this was considered a less serious violation of the CCC guidelines, it was still not an ideal choice in terms of programming.

27 Livio Fantina'I giudizi del CCC', *Storia del cinema italiano 1949-1953* (Venice: Marsilio Editori, 2003), pp. 80-90.
28 CCC moral judgement available in the *Dizionario del Cinema*.
29 'Several shoot-out scenes and violent acts' (ibid.).
30 'Numerous scenes of violence, ambushes, fights, battles' as well as 'revealing costumes' (ibid.).
31 'It is the film which supports or represents in a persuasive manner an immoral thesis (divorce, homicide, rebellion against the authority, irreverence towards religion, etc.) or that, even if presenting episodes indifferent or even positive, still has sequences and dialogues which are seriously immoral' ('Prospetti statistico-morali dei film proiettati in Italia dal 1934 al 1962', *Guida cinematografica*, CCC, [Officina Grafica Commerciale, Rome, 1963], p. XLVI).
32 Civardi, pp. 178-180.

Conclusions

While the CCC classifications had 'statutory validity' for parish cinemas' exhibitors,[33] at the same time transgressing these rules was not only inevitable, but at times implicitly condoned by the Catholic Church. In fact, as, ideally, productions inspired by Catholic principles should have been the main supplier for religious venues, in practice the lack of suitable works forced parish exhibitors to screen also films deemed to be problematic from a Catholic perspective. The analysis of the programming data presented in this chapter demonstrates that the classifications' inconsistency and lack of transparency in terms of criteria makes it very difficult to compare film ratings against moral judgements.[34] Moreover, it shows that the Catholic Church's attempt to moralise programming in parish cinemas was only partially successful. This was not just a consequence of the lack of Catholic film production. It was also due to the complexity of the Catholic film exhibition sector, which had to meet the needs of running a profitable business, while responding to the pressures of the ecclesiastic establishment. The educational intentions of parish cinema networks had to be compromised by the desire to attract audiences, forcing constant adjustments in the programming which at times would disrespect the CCC guidelines. The constant clash between opposing needs and pressures created a polarization of the theory and practice of Catholic censorship and moral control over film content, causing unruly and unpredictable programming patterns within the parish cinemas' exhibition network.

References

Bernardi, Aldo, 'Sull'attività dei cinema cattolici', *Bollettino dello spettacolo*, (3 Feb 1955), Year XI, n. 223, 5.
Bongioanni, Marco, *Cinema, Caso di coscienza* (Asti: Libreria Dottrina Cristiana, 1962).
Civardi, Luigi, 'Criteri di valutazione morale dei film', *La Rivista del Cinematografo*, Vol. 10 (1940), 178-80.

33 Bongioanni, p. 29.
34 In relation to this, see Albino Galletto, 'E' facile giudicare un film?', *La Rivista del Cinematografo*, Year XXIII, n. 4, April 1950, p. 5.

Covi, Antonio, 'Nostro cinema', *La Rivista del Cinematografo*, Year XIV (20 June 1941), n. 6, 84-85.

Dalla Zuanna, Francesco, 'A.C.E.C.: Anno dieci', *La Rivista del Cinematografo*, Year XXXII (September-October 1959), Supplement to n. 9-10, 9-12.

'L'esercizio cattolico', *La Rivista del Cinematografo*, (1956), n. 6-7, 26-27.

De Mori, Giuseppe, 'Il cinema e i criteri di censura', *La Rivista del Cinematografo*, Year XI (20th May 1938), n. 5, 105-07.

Dizionario del Cinema (Commissione Nazionale Valutazione Film [CD-rom]).

'Esortazione del Sommo Pontefice sulla classificazione morale dei film', *Lo Spettacolo*, Year 54 (Oct-Dec 1954), Vol. IV, n. 4, 47.

Fantina, Livio, 'I giudizi del CCC', *Storia del cinema italiano 1949-1953* (Venice: Marsilio Editori, 2003), pp. 80-92.

Galletto, Albino, 'Diritti e doveri delle sale cattoliche', *La Rivista del Cinematografo*, Year XXIII, n. 1, January 1950, pp. 3-4.

'E' facile giudicare un film?', *La Rivista del Cinematografo*, Year XXIII (April 1950), n. 4, 5.

'I giudizi morali sui film', *La Rivista del Cinematografo*, Year XXIII (February 1950), n. 2, 5.

'L'ufficio permanente nazionale di revisione', *La Rivista del Cinematografo*, Year XXIX (June-July 1956), n. 6-7, 9-10.

'Il Gazzettino delle grane', *Bollettino dello spettacolo*, Year X (10 November1954), n. 214, 1.

Guida Cinematografica (Rome: Centro Cattolico Cinematografico, 1963), p. LXIII.

Laccisaglia, M. 'Sale parrocchiali: concorrenza a fin di bene', *Bollettino dello spettacolo*, Year VIII (31st January1952), n. 138, 3.

Lettera Pontificia Commissione per la Cinematografia (1st June 1953, n. 246).

Pius, Miranda Prorsus: On Motion Pictures Radio & Television: Encyclical Letter of His Holiness Pope Pius Xii, September 8, 1957. http://w2.vatican.va/ content/pius-xii/en/encyclicals/documents/hf_p-xii_enc_08091957_ miranda-prorsus.html#Nota%2038 [accessed 28 August 2015].

Mosconi, Elena, *L'impressione del film: contributi per una storia culturale del cinema italiano, 1895-1945* (Milan: Vita e Pensiero, 2006).

Rossi, Enrico, *Lo Stato cinematografaro* (Florence: Parenti Editore, 1960).

'Sanzioni contro cinema parrocchiali', *Bollettino dello spettacolo*, YearVIII (31st March 1952), n. 142, 2.

Treveri Gennari, Daniela and J. Sedgwick, 'Memories in context: the social and economic function of cinema in 1950s Rome', *Film History*, vol. 27 (2015), n. 2, 76-104.

Treveri Gennari, Daniela, 'Moralizing Cinema while Attracting Audiences: Catholic Film Exhibition in Post-War Rome', in *Moralizing cinema: Film Catholicism and Power*, ed. by Daniel Biltereyst and Daniela Treveri Gennari (New York: Routlege, 2014), pp. 275-285.

'Una rigorosa indagine sulla disciplina dei parrocchiali, *Bollettino dello spettacolo*, Year XII (14 January 1956), n. 272, 4.

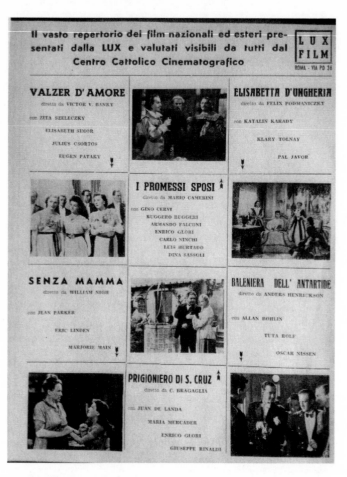

Distribution companies film advertising approved by the
Catholic Cinema Centre

FRAMING BELIEF
PASOLINI AND PETRI

LAURA RASCAROLI

AN IMMANENT SUBLIME
On the Figure of Christ in Pier Paolo Pasolini's
Il Vangelo secondo Matteo

He is a riddle, the Virgin's Son / who stands to pronounce the
blunt one-liners / of the Sermon on the Mount.[1]

Marxism must face the religious moment of humanity. There
will always be an irrational, religious moment.[2]

Pier Paolo Pasolini's sixth film, *Il Vangelo secondo Matteo* (*The
Gospel According to St. Matthew*, 1964) is one of the most famous,
debated, 'classical' examples of the encounter between cinema and
the Catholic Church in Italy. The history behind this encounter is
well known, and was thus summarised by Nathaniel Rich:

> Recent large-scale reforms at the Vatican, following the election of the
> liberal Pope John XXIII in 1958 and the creation of the Second Vatican
> Council in 1962, had encouraged the Church to look for new ways to
> spread its message. In this spirit, John XXIII had ordered the Pro Civitate
> Christiana, or Cittadella, a Franciscan study center at Assisi, to help 'lead
> society back to the principles of the Gospels' by encouraging better
> relations between the Church and prominent cultural figures. Pasolini
> accepted an invitation to attend a Cittadella conference in 1962, and after
> reading a copy of the gospels in his room, he was inspired to make *The
> Gospel According to Saint Matthew*. The Franciscan leaders of the Cittadella
> were persuaded, and their endorsement encouraged reluctant investors.[3]

1 Gerard Smith, 'According to Matthew', *New Hibernia Review / Iris
 Éireannach Nua*, 9.3 (2005), 42, p. 42.
2 Pasolini quoted in Naomi Greene, *Cinema as Heresy* (Princeton: Princeton
 University Press, 1990), p. 71.
3 Nathaniel Rich, 'The Passion of Pasolini', *New York Review of Books*, LIV.14

The film has often been described as a surprisingly (given Pasolini's rejection of Catholicism and his Marxist ideological positions) orthodox reading and almost an illustration of St Matthew's Gospel, an idea further corroborated by the Catholic Church's enthusiastic reception of the film, epitomised by the bestowal on it of the Organisation Catholique Internationale du Cinéma et de l'Audiovisuel (OCIC) Award at the 1964 Venice Film Festival.[4] In 2014, on the fiftieth anniversary of the film's release, *L'Osservatore Romano*, the daily newspaper of Vatican City State, described it as probably the best film ever made on Jesus, thus confirming the opinion of its orthodoxy.[5] Critics, however, as we will see in greater detail below, have also highlighted elements that contradict this reading, such as the immanentisation effected by Pasolini on all the transcendental elements of the Gospel, the portrayal of Christ as a pre-Marxist, super-human hero, rather than a supernal God, and the recurrence in the film of Pasolinian tropes and obsessions, especially the take on those who are excluded from history: the marginalised, peripheral subproletariat.[6] Indeed, Pasolini's so-called period of 'ideological cinema', which goes from *La rabbia* (1963) to *Uccellacci e uccellini* (*Hawks and Sparrows*, 1966), has been described as the years of his most radical isolation and sociopolitical torment, in which he confronted and deplored the crisis of a country in deep transformation, perceived as steep decline and loss of invaluable cultural and aesthetic traditions.[7] In this contribution, I will focus on the figure of Christ in *Il Vangelo secondo Matteo* with a view to arguing that, in spite of the project of immanentisation clearly pursued by Pasolini, an effect of sublimity is nevertheless achieved, resulting in a complex and contradictory portrayal in

(2007), pp. 77-80 <http://www0.cs.ucl.ac.uk/staff/D.Quercia/others/passion.pdf> [accessed 14 August 2015].

4 As Rich has described, 'when it was specially screened for a group of Vatican prelates, it received a twenty-minute ovation'.

5 'Scolpito nella pietra. Cinquant'anni fa usciva *Il Vangelo secondo Matteo* di Pier Paolo Pasolini', *L'Osservatore romano*, 21 July 2014 <http://www.osservatoreromano.va/it/news/scolpito-nella-pietra> [accessed 26 August 2015].

6 Lino Miccichè, *Pasolini nella città del cinema* (Venice: Marsilio Editori, 1999), pp. 46-8.

7 Miccichè, p. 33.

which lies much of the affective outcome of the film. The issue of how to read the 'unfathomable problem' of such sublimity is decisive if one is to respond to Gilles Deleuze question, asked with reference to Pasolini's *Teorema* (*Theorem*, 1968): 'Was this Pasolini's way of still being Catholic? Was it on the contrary his way of being a radical atheist?'.[8] This question is, of course, not an end in itself; rather, it is functional to an understanding of the cinema of Pasolini as a cinema in which thought is immanent to the image; a cinema of Artaudian cruelty, which 'does not tell a story but develops a sequence of spiritual states which are deduced from one another as thought is deduced from thought'.[9] While not a Catholic ('I think I am the least Catholic of all the Italians I know'[10]), Pasolini was raised as one and, according for instance to art historian Federico Zeri, who met him personally several times, his relationship with religion was ambiguous:

> Pasolini, in my opinion, was deeply Catholic, in his heart; he grew up in Catholic Italy, and therefore had a strong sense of sin, a strong sense of redemption, a strong sense of liberation from sin and from guilt. I think this was Pasolini. He [...] always gave me the impression of being deeply touched by guilt, of being an agitated, almost tormented and torn person.[11]

The many Christological elements present in much of Pasolini's oeuvre, as well as his notorious, controversial identification with the figure of Christ, have been frequently highlighted and thoroughly explored. In spite of his repudiation of Catholicism, throughout his life Pasolini appeared to elect Jesus as the ideal embodiment of a 'scandalous' mode of existence, characterised by protest and resistance in the face of mainstream powers. It is also important here to reference the Christological subtext of

8 Gilles Deleuze, *Cinema 2: The Time-Image* (London: Continuum, 1989), pp. 175-6.
9 Deleuze, *Cinema 2*, p. 174.
10 Pier Paolo Pasolini, and Oswald Stack, *Pasolini on Pasolini: Interviews with Oswald Stack* (London: Thames and Hudson, 1969), p. 14.
11 Transcription of an interview with Federico Zeri from the TV programme *Pasolini e noi* (1995), in 'Pier Paolo Pasolini secondo Federico Zeri', *Pier Paolo Pasolini: La saggistica* <http://www.pierpaolopasolini.eu/saggistica_zerisupasolini.htm> [accessed 14 August 2015]. My translation.

his three pre-Gospel feature films, *Accattone* (1961), *Mamma Roma* (1962), and *La ricotta* (1963), each of which presents characters that are associated with the Passion and die in a Christ-like manner: respectively, Accattone (Franco Citti) in the company of two thieves; Ettore (Ettore Garofolo) strapped to a constraining table, with his arms outstretched in a cruciform; and Stracci (Mario Cipriani) no less than on a cross, although one found on a film set. The presence of an element of identification by the author with the figure of Christ — with his anguish, and with his body displayed on the cross as the site of a scandal — is most overt in his poem 'La crocifissione' ('The Crucifixion'):

> One must expose oneself (is this what / poor Christ nailed up teaches us?) / [...] We shall be offered on the cross, pilloried, exposed to pupils / limpid with ferocious joy [...] / to bear witness to the scandal.[12]

Pasolini had in fact already mentioned his sensuous identification with Christ as early as 1946, in a diary entry in which he described a recurrent fantasy:

> to imitate Christ in his sacrifice for others and to be condemned and killed despite being innocent. I saw myself hanging on the cross, nailed up. My thighs were scantily covered by that light strip of cloth, and an immense crowd was watching me. My public martyrdom ended in a voluptuous image and slowly it emerged that I was nailed up completely naked.[13]

In *Il Vangelo secondo Matteo*, then, Pasolini's autobiographical identification is already suggested extratextually by the author's original wish to cast a famous poet, either Yevgeni Yevtushenko or

12 Bisogna esporsi (questo insegna / il povero Cristo inchiodato?), / [...] noi staremo offerti sulla croce, / alla gogna, tra le pupille / limpide di gioia feroce [...] / per testimoniare lo scandalo. Pier Paolo Pasolini, 'La crocifissione' (1948-49), in *Tutte le poesie*, ed. by Walter Siti, Vol. 1 (Milan: Bruno Mondadori, 2003), pp. 467-8. My translation.
13 My translation. Pier Paolo Pasolini, 'Quaderni rossi del 1946', in *Pasolini, Lettere*, vol. I (1940-1954), ed. by Nico Naldini (Turin: Einaudi, 1986), Cronologia, p. XX.

Jack Kerouac, to play Christ in the film,[14] and by his choice to cast
his mother as the older Virgin Mary, and some of his friends as
apostles (Alfonso Gatto, Enzo Siciliano, Giorgio Agamben) and
as Mary of Bethany (Natalia Ginzburg). The projection of the
film on Pasolini's body during *Intellettuale*, an installation by Fabio
Mauri performed at the Modern Art Gallery of Bologna on 31 May
1975,[15] confirms these subtexts, for it is suggestive simultaneously
of the corporeality of Pasolini's cinema and of its inscription onto
the authorial body, which 'bears' the film like a cross.

According to Adelio Ferrero, in *Il Vangelo secondo Matteo* the
autobiographical and lyrical identification with Christ, which
gestures towards Pasolini's understanding of himself as a martyr,
and of his body and persona as the site of a scandal, is never
allowed to become an 'object of static contemplation or inert
dreaminess'.[16] Indeed, his identification is counterbalanced for
Ferrero by the representation of Christ as a proto-Marxist hero, as
a symbol of protest and violent rejection of the norm of iniquity
and evil. While the film is indeed devoid of narcissistic dreaminess,
it is however important to acknowledge the potential reading of *Il
Vangelo secondo Matteo*'s proto-Marxist Christ as an embodiment of
the organic intellectual—in other words, of Pasolini himself, and
his outspoken position against the evils of neocapitalism. This
aspect, which has been highlighted by all critics, is connected at
once to the autobiographical features of Pasolini's Christ and to
the question of his immanentisation. As Lloyd Baugh has written:

> In Matthew, Jesus is more than once identified as the Messiah,
> but Pasolini removed certain aspects of his divinity: the most
> important miracles, the Transfiguration and the corresponding
> confessions of faith in Jesus, the references to God's Kingdom in
> Jesus's preaching, and many parables are missing.[17]

14 *Pasolini on Pasolini*, p. 78.
15 Fabio Mauri, '*Intellettuale* (1975)', 'Proiezioni', *fabiomauri.com*
 <http://www.fabiomauri.com/it/proiezioni/intellettuale.html>
 [accessed 23 August 2015].
16 My translation. Adelio Ferrero, *Il cinema di Pier Paolo Pasolini* (Venice:
 Marsilio, 1994), p. 57.
17 My translation. Lloyd Baugh, 'La rappresentazione di Gesù nel cinema:
 problemi teologici, problemi estetici', *Gregorianum* 87.4 (2001), pp. 199-
 240 (p. 237).

Pasolini's identification with Christ, furthermore, must be seen in the context of the grounding of his poetic world in the figure of the 'I'. Robert Gordon has detected and explored a number of modalities of the expression of the self in Pasolini's poetry, journalistic output, and cinema, which go from the presence of autobiographical data to the identification or refiguration of the speaking subject in fictional or mythical figures, from specific stylistic tropes to the writing of the self into ideas of history, ideology, and myth. As Gordon has clarified, '[a]ny discussion of the role of self-construction in Pasolini must start from the primary and absolute importance assigned in his value system to selfhood and to the potentially overwhelming expressivity of the self and his desires'.[18] For Gordon, then, the value of the private sphere in Pasolini resides simultaneously in its innocence and authenticity, and in its projection onto a public role. This dynamic is based 'on a paradoxical combination of expression of the self's innermost, guilt-ridden being and an apparent inability to control or dictate the terms of expression'.[19] In other words, the self's innocence ultimately attest to the authenticity of its public expression. Against the backdrop of this complex understanding of the authorial 'I', it becomes possible to see Christ as a figure capable at once of representing Pasolini's (Catholic) anxiety and guilt, and of incarnating the myth of the innocence and authenticity of the self — in other words, as the site of a paradox. In this essay, I will contend with the nature of this paradox, as specifically articulated in *Il Vangelo secondo Matteo*.

An established critical tradition, as mentioned, sees Pasolini's film as profoundly faithful to the Gospel according to St Matthew — a tradition that was initiated and corroborated by Pasolini's own declarations before and during the making of the film; he claimed, for instance: 'I haven't changed a single word of the holy text'.[20] In an essay on 'The Texts of *Il Vangelo secondo Matteo*', Zygmunt Baranski has forcefully argued against this tradition. By analysing

18 Robert Gordon, 'Pasolini's Strategies of Self-construction', in *Pasolini Old and New: Surveys and Studies*, ed. by Zygmunt G. Baranski (Dublin: Four Courts Press, 1999), pp. 41-76 (p. 42).

19 Gordon, p. 42.

20 Pasolini quoted in Zygmunt G. Baranski, 'The Texts of *Il Vangelo secondo Matteo*', in *Pasolini Old and New*, pp. 281-320 (p. 284).

and comparing the text of the Gospel with Pasolini's screenplay and with the film, and by engaging with interviews that Pasolini gave before the making of the film and after its release, Baranski has argued that, far from being passively faithful to St Matthew, the film operates a series of choices that become visible in what is kept and what is omitted of Christ's words and of episodes of his life as narrated in the Gospel, as well as in relation to point of view, narrative style, and commentary. Some of the most significant of these choices include the elision of over half of Jesus's words, the exclusion, modification, or combination of several episodes, the reduction of the over twenty miracles in St Matthew to only six in the film, the multiplication of point of view, and the emphasis on figures other than Christ. Pasolini's approach is consequently read by Baranski not as the simple result of a translation of the written text into an audiovisual one, a translation governed by the rules of adaptation, but as a radical distancing from the Gospel, and as subversion of the figure of Christ as depicted by St Matthew. For Baranski, indeed, Pasolini's Christ is conditioned by the director's own 'increasing reaffirmation of a secular political commitment during 1964'.[21] In particular, he describes Pasolini's Christ as different from both the one in St Matthew and the one in the film's original screenplay; in the latter, in fact, Pasolini presented 'an exaggeratedly lyrical and melodramatic portrayal of Christ, while in the film he concentrated on his human attributes'.[22] Baranski describes the filmic figure as humanly 'nervy, irritable, moody, only rarely compassionate'; his 'angers are swift', and sometimes barely justified:

> He lacks any kind of divine serenity, but is prey to human emotions. Pasolini's Jesus in the film has lost the calm and stability of his earlier counterpart. Instead he is driven and torn by conflicting powerful passions which are never properly explained.[23]

Pasolini's Christ emerges from Baranski's reading as an ambiguous, polyvalent, and irrational humanised figure that

21 Baranski, 'The Texts', p. 305.
22 'The Texts', p. 306.
23 'The Texts', pp. 307-8.

defies explanation. While 'the director obsessively watches him, employing a variety of camera positions, movements and angles, using lenses of different focal length, and establishing different narrative points of view',[24] the mystery remains unsolved, because each perspective is necessarily limited. For Baranski, thus, Christ in Pasolini's film is ultimately unfathomable, for he means different things to the different people who observe him.

While Baranski's highly informed analysis is cogent, my reading diverges from the conclusions he draws from it; it also dissents with those critics who only see immanent aspects in Pasolini's Christ, such as Kostas Myrsiades, who claimed that '*The Gospel According to St. Matthew* brings the common man back to his own control over biblical events and to a view of Christ as revolutionary';[25] or Richard Walsh, who wrote that 'In Matthew, Pasolini finds class conflict, not divine revelation, and a social, not a spiritual message'.[26] I will argue that Pasolini's figure is not so much irrational and unfathomable as paradoxical, in its being at once immanent and sublime. The paradox was of course inherent in the encounter of a radical intellectual with the Catholic Church; in Pasolini's own words, '*Il Vangelo secondo Matteo* [...] was a sort of concrete act of dialogue and relationship between a communist, although not a member of the Party, and the most advanced forces of Italian Catholicism'.[27] Here, however, I will do more than simply suggest a paradoxical copresence in the film of unresolved contrasting elements, such as immanence and transcendence, or Marxism and Catholicism, or the text of the Gospel and two thousand years of readings of it — not least because what we see

24 'The Texts', p. 310.
25 Kostas Myrsiades, 'Classical and Christian Myth in the Cinema of Pasolini', *College Literature*, 5.3 (Fall 1978), pp. 213-18 (p. 217).
26 Richard Walsh, *Reading the Gospels in the Dark: Portrayals of Jesus in Film* (Harrisburgh, PA: Trinity Press International, 2003), p. 103.
27 My translation. Pasolini, in *L'avventurosa storia del cinema italiano raccontata dai suoi protagonisti: 1960-1969*, ed. by Franca Faldini and Goffredo Fofi (Milan: Feltrinelli, 1979), p. 241. On the dialogue between Pasolini and Pro Civitate Christiana see Tommaso Subini, 'Il dialogo tra Pier Paolo Pasolini e la Pro Civitate Christiana sulla sceneggiatura de *Il Vangelo secondo Matteo*', in *Attraverso lo schermo. Cinema e cultura cattolica in Italia*, ed. by Ruggero Eugeni and Dario E. Viganò, Vol. II (Rome: EdS, 2006), pp. 223-37.

as a contradiction was not so in Pasolini's mind.[28] The paradox is there, but it is filmic as much as it is philosophical, ideological, and cultural; and it is precisely the filmic paradox that I wish to highlight and explore. In so doing, I aim to shed light on the affectivity of Pasolini's Christ as an entirely filmic sublime. This is in line with Jean-Luc Nancy's use of Pasolini as an example of what he sees as the post-Christian replacement of the sacred by art, and of his claim that the subject of Christian art is not religion, but art itself.[29] Equally, it is in accordance with Deleuze's reading of Pasolini as the director most committed to giving up metaphor and metonymy and using the camera-pen to write 'with camera-movements, high-angle shots, low-angle shots, back-shots', thus carrying the image 'to the point where it becomes deductive and automatic', and reaching a rigour of 'the thought of the image, the thought in the image'.[30] In *Il Vangelo secondo Matteo*, I claim, filmic technique opens up new meanings of 'holiness'.

Baranski, among other critics, has described the film as displaying a significant measure of reticence as well as good taste. The film undeniably refrains from the 'low', scandalous subject matter that can be found in much of Pasolini's early production; yet, I will reframe it as an excessive rather than as a sober film. The direct comparison of the film with the Gospel may produce an impression of verbal scarcity; if, however, one considers the film not in conjunction with the Gospel, but in and of itself, I would argue that the opposite becomes evident: an impressive logocentrism. The film's verbal excess is all the more affective in the light of the fact that all its dialogue is based on the Gospel; thus, only the divine word is heard in the film, even when characters

28 As Paolo Vittorelli has argued, such lack of contradiction does not lie in the fact that Pasolini was at once a radical revolutionary and a pro-clerical reactionary, but that he was animated by the same, coherent independence of judgment in expressing both his political and his religious opinions. Paolo Vittorelli, '*Il vangelo secondo Matteo*. Pasolini e il sacro: "Crist al mi clama / ma sensa lus"', *Philomusica on-line*, 6.3 (2007) <http://riviste.paviauniversitypress.it/index.php/phi/article/view/06-03-INT09/82#_ftnref1> [accessed 26 August 2015].

29 Jean-Luc Nancy, *The Ground of the Image* (New York: Fordham University Press, 2005), p. 1-14.

30 *Time-Image*, p. 174.

other than Christ speak. Furthermore, most of the film's speech comes directly from a divinity: Christ, an angel, and God.

The film can be thought of as organised into three parts: the first, from the annunciation to the episode of John the Baptist's christening of Jesus, presents us with the well-known elements of the story of Christ until he becomes a young man; the second section includes the temptation in the desert, the sermons, the miracles; the final part goes from the entrance into Jerusalem to the trial, crucifixion, and resurrection. When Jesus starts to speak in the film, coinciding with his christening, he never stops again. His is a veritable river of words. In particular, Pasolini edits his sermons all together, with little respite, forming a long series of sequences that occupies the whole central section of the film. The effect is striking, and rather overwhelming, also because little to no action takes place; it is as if the narrative were suspended. As Pasolini once noted in an interview, in St Matthew's gospel he liked 'the elliptical jumps within the story, the disproportions of the moments of didactic stasis (the stupendous, interminable sermon on the mount)'.[31] This disproportion points not to sobriety, but to excess, one that creates an intense affectivity in the film.

Much of the affect that is mobilised by these sequences is conveyed by the use of the close-up, which is overwhelmingly prevalent in the film.[32] More than half of its 1129 frames are, in fact, close-ups — an extraordinary proportion that brings to mind another film based on the Passion iconography that experimentally foregrounds the close-up: Carl Theodor Dreyer's *Passion of Joan of Arc* (1928).[33] In Pasolini's film, the face of Christ is frequently at the centre of the frame, closely scrutinised by the camera.[34] Of course, the close-up is always an affective shot;

31 My translation. Pasolini in *L'avventurosa storia*, p. 242.

32 The film also makes immoderate use of zoom shots.

33 This is effectively emphasised by Jean-Luc Godard, who included the whole sermon on the mount from Pasolini's film in Chapter 3(b) of his *Histoire(s) du cinema* (1988/1998) and intercut a close-up of Pasolini's Christ with a close-up of Joan of Arc in tears taken from Dreyer's film.

34 The close-up focus on Christ, however, ceases in the last section of the film, in which Pasolini, like Matthew, produces a distancing from Christ that suggests his progressive isolation, as Bart Testa has remarked. Bart Testa, 'To Film a Gospel ... and Advent of the Theoretical Stranger', in

for Deleuze, in fact, it is the epitome of the affection-image: '*The affection-image is the close-up, and the close-up is the face*'.[35] In Deleuzian terms, affect expresses itself outside spatio-temporal coordinates; as Ronald Bogue has written:

> The close-up *is* the face in that the close-up *facializes*, or converts a concrete entity into a decontextualized immobile surface with motor tendencies that expresses an affective quality/power. Affect, thus, is not strictly human.[36]

In *Il Vangelo secondo Matteo*, techniques including framing, lighting, editing, and voice all contribute to create a particular affectivity, which is not strictly human, as I shall now describe and explore. Firstly, however, it is helpful to consider Pasolini's casting choice. Cinematographer Tonino delli Colli reported that the film's producer Alfredo Bini received from an American producer the offer of one billion italian lire of the time, conditional on casting Burt Lancaster in the role of Jesus.[37] The film was instead made for 200 million lire, casting a nonprofessional actor, Catalan student Enrique Irazoqui, who had sought a meeting with Pasolini (among other Italian intellectuals) as a representative of the clandestine leftist unions under Franco's dictatorship.[38] Irazoqui could not be more unlike Lancaster's athletic and romantic masculinity, on the one hand, and the popular iconography of Christ, and existing Hollywood representations of Jesus, on the other hand. Precisely his looks were at the root of his selection, one that was influenced by Pasolini's art-historical approach to the film's mise en scène. As Pasolini explained in an interview:

Pier Paolo Pasolini: Contemporary Perspectives, ed. by Patrick Allen Rumble and Bart Testa (Toronto: University of Toronto Press, 1994), pp. 180-209 (pp. 194-5).

35 Gilles Deleuze, *Cinema 1: The Movement-Image* (London: Continuum, 1989), p. 87. Emphasis original.

36 Ronald Bogue, *Deleuze on Cinema* (London: Routledge, 2003), p. 34. Emphasis original.

37 See *L'avventurosa storia*, p. 242.

38 Enrique Irazoqui, and Mariano Sigman, 'Intervista a Enrique Irazoqui', *pasolini.net* <http://www.pasolini.net/cinema_intervistaIrazoqui.htm> [accessed 14 August 2015].

I did not want a Christ with soft features and a sweet look, as in
the Renaissance iconography; I wanted a Christ whose face would
also express strength, decisiveness, a face like that of Christ in
medieval paintings. A face, in other words, that would correspond
to those arid and stony places in which Christ preached.[39]

In the same interview, Pasolini also commented that Irazoqui
had the face of an El Greco Christ. El Greco's images are, however,
somewhat too angelic next to Irazoqui's Christ, who is much closer
to the Byzantine image of the severe Christ Pantocrator, as Millicent
Marcus has also remarked.[40] The evocation through Irazoqui of the
all-powerful Christ Pantocrator, who is stern but compassionate,
is an important basis, I claim, for the effect of sublimity produced
by the film. The Byzantine Christ Pantocrator has been read by
art historians as a sublime figure; indeed, Byzantine art in general
has been seen as sublime art that evokes exaltation and appeals to
emotions, in opposition to Classical Greek art, which aims for beauty,
and thus for calm and serenity.[41] The choice of representing Christ,
rather than God the Father, as the ruler of all, was an iconographical
shift that took place in the fourth century.[42] His figure was normally
depicted half-length, in a manner that recalls Pasolini's choice of
framing his Christ in close-up.

Not only is Christ often framed in close-up; as illustrated by
Figures X–Y, while the camera in Pasolini's film is often placed
in a frontal position, looking straight at Christ's head, framing is
also used to construe Christ's presence as striking and arresting;
indeed, we observe him either from below, from one side, or
even (and very unusually) from behind, in ways that accentuate
his aura, his dominion of the frame, his inscrutability, his power
to attract the gaze of the camera lens and to keep it fixed

39 My translation. *L'avventurosa storia*, p. 242.
40 Millicent Joy Marcus, *Filmmaking by the Book: Italian Cinema and Literary
 Adaptation* (Baltimore and London: Johns Hopkins University Press,
 1993), p. 123. In light of Pasolini's already mentioned considerations on
 Irazoqui's resemblance to an El Greco painting, it is also interesting to
 note that El Greco himself painted the Christ Pantocrator several times.
41 Konstantinos G. Niarchos, 'The Beautiful and the Sublime: From Ancient
 Greek to Byzantine Art and Thought', *Diotima* 10.1, 1982, pp. 81-99.
42 Hellemo, Geir. *Adventus Domini: Eschatological Thought in 4th-century Apses
 and Catecheses* (Leiden: E. J. Brill, 1989), pp. 7-14.

(transfixed) on himself. Lighting is also employed in ways that transfigure his image; at times, Pasolini allows the light to hit the lens, creating almost a supernatural image; other times, he overexposes or underexposes Irazoqui's face, thus alternately emphasising the bright background or the foreground; on occasion, he submerges his face in darkness, and plays with lights that mimic an electric storm and express the Pantocrator's divine fury. What is more, framing is used in ways that emphasise Christ's dominion over space. Partly because of the barren landscapes against which he is seen, partly on account of his positioning in the frame, space around him is often flattened, and seems emptied out. His figure is thus firmly placed outside place-time coordinates, taking on a supernal quality.

In his early films, Pasolini famously employed a frontal approach to framing that was strongly pictorial and 'sacred'; as many critics have pointed out, and as Pasolini himself has conceptualised, the combination of pictorial frontality, religious iconography, and sacred music created an almost impossible (and scandalous to the Church and to conservatives) effect of sacralisation of the lowly content matter and of his subproletariat characters.[43] This style was not adopted in *Il Vangelo secondo Matteo*; in interviews, Pasolini explained that, after he started shooting the film according to the same criteria, he quickly realised that this style was excessive for a content matter that was already high and sacred in itself, and thus started to experiment with new approaches.[44] The use of a different lens (300mm), in particular, 'obtained simultaneously two effects: that of flattening and then rendering the figures even more pictorial (Quattro and Cinquecento), and at the same time the effect of endowing them with the casualness and immediacy of a news documentary'.[45] As Noa Steimatsky has

43 See, for instance, Pier Paolo Pasolini, 'Pier Paolo Pasolini: An Epical-Religious View of the World', *Film Quarterly*, 18.4 (Summer 1965), pp. 31-45.

44 *Pasolini on Pasolini*, pp. 83-4.

45 Pier Paolo Pasolini, 'Confessioni tecniche', in *Uccellacci e uccellini* (Milan: Garzanti, 1966), pp. 44-6. Cited in and translated by Noa Steimatsky, 'Pasolini on Terra Sancta: Towards a Theology of Film', in *Rites of Realism: Essays on Corporeal Cinema*, ed. by Ivone Margulies (Durham and London: Duke University Press, 2003), pp. 245-69 (pp. 247-8).

noted, the 'increase of focal length in *Il Vangelo* does not always allow for centralized composition, but the sense of frontality is nonetheless accentuated' through the flattening of the image.[46] This ultimately produced the mix of reverential, static formalism and of *cinéma vérité*, documentary-like approach that characterises the finished film. Naturalism and realism, in fact, amalgamate in *Il Vangelo secondo Matteo* with an epic/sacramental tone; and the superimposition of historical past and presentness contribute to the paradoxical mix. As Pasolini explained:

> [H]ow could I fashion Herod's soldiers? I dressed them a bit like Fascists and imagined them to be like Fascist gangs or like the Fascists who used to kill Slav babies by throwing them up in the air. How did I imagine Joseph and Mary's flight into Egypt? I imagined it remembering certain flights, certain evacuations of Spanish refugees across the Pyrenees.[47]

The eclecticism and temporal unevenness of the visuals is paralleled in the soundtrack, in which Bach and Mozart alternate with folk music by civil-rights singer-songwriter Odetta (Odetta Holmes), and with contemporary music by Czech composer Leoš Janáček.

The style of Pasolini's film is, indeed, highly eclectic, one might even say chaotic — an aspect and a term to which I will return later. For the moment, it is useful to highlight how Pasolini's aesthetic approach to the figure of Christ, especially in the central section of the film, produces a progressive, cumulative, distinct affectivity through mise en scène, and in particular through the intense close-up focus on Christ's face; the conjunction of a flattening of the image, produced by the lenses, and the unusual, experimental, expressive framing; the production of an empty, hollow space; the expressionistic lighting effects; and, not yet mentioned, but equally important, the unusually frequent fades to black, which disrupt and fragment the narrative flow, amounting to the 'irrational cuts' that, for Deleuze, characterise the time-image, and producing an unfathomable temporality. To these techniques, the intense logocentrism of these sequences, in

46 Steimatsky, p. 248.
47 Quoted in Baranski, 'The Texts', p. 287.

which Christ's words flow uninterruptedly, addressing the spectator in monologue form, must be added. It is crucial to stress that his voice was not recorded in a naturalistic manner; firstly, Irazoqui was dubbed by an Italian actor (Enrico Maria Salerno); secondly, the voice is not synchronised to the image, thus sounding either distant or close to the microphone, according to whether the camera is near or far from the actor, but is independent of it; the sound, in other terms, is always in close-up.[48] As such, the voice is like a distinct entity, and otherworldly; it is a 'voice of God' that is singularly affective, for it is at once supernatural and originating from an earthly body.[49]

It is possible to describe this particular, intense affectivity in terms of an effect of sublimity, which deeply contrasts with, and counterbalances, that process of immanentisation of all divine aspects that many critics have highlighted in the film. However, this is not equivalent to the sublime that periodically flashes up in Pasolini's previous films, where, as previously remarked, frontality, fixity, Christological iconography, and sacred music created a sense of the transcendental paradoxically coupled with 'low' subjects, such as thieves, pimps and prostitutes. In those films, the transcendental was achieved via a technique that strongly evoked sacred art. *Il vangelo secondo Matteo* also references sacred art (the Byzantine Christ Pantocrator and Italian Renaissance) through iconography and composition; however, the transcendental moments it creates are, for the first time in Pasolini, strongly linked to filmic technique, to a camera-pen that 'carries out a construction';[50] and in particular, as we have seen, to framing, photography, editing, and sound used in highly expressionistic, experimental ways. It is a more specifically filmic (as opposed to art-historical) and, thus, more immanent sublime, which could be described as an excess in the use of affective filmic techniques. Such excess could be read in Deleuzian

48 For a punctual analysis of the dubbing of Christ's voice in the film, see Maurizio Viano, *A Certain Realism: Making Use of Pasolini's Film Theory and Practice* (Berkeley, Los Angeles, London: University of California Press, 1993), p. 138. On voice and sound in Pasolini's film, see also Steimatsky, pp. 249-50.

49 A film by Dreyer that, similarly to Pasolini's *Il Vangelo secondo Matteo*, uses the literal word of God spoken by an 'alienated' actor's voice to create an affective excess and an immanent sublime is *Ordet* (*The Word*, 1955).

50 Deleuze, *Time-Image*, p. 174.

terms as intensity, or as *sentiendum*, as that 'which cannot be felt since it always exceeds the sensible and the experienceable. But at the same time it has to be felt and can be nothing but felt'.[51] We could equally read it as a cinematic *jouissance*, as a surplus of filmic pleasure. Drawing Jacques Lacan into the equation is tempting, not only because Pasolini's autobiographical reading of the figure of Christ and his narcissistic identification with Christ's body exposed on the cross could easily trigger a psychoanalytical reading, but also on account of the crucial role of language and speech in Lacan's theory, and specifically of voice as *objet petit a*, the object cause of desire, an element that is imagined as separable from the rest of the body (as Christ's voice is in the film, as a consequence of the lack of synchronisation with the image). Speech and voice are, I argue, the most unrestrained, transgressive elements of Pasolini's *Il Vangelo secondo Matteo*.

It is also possible, however, to leave Lacan to one side, and focus on the cinematic nature of this sublime, as I have done in this essay, as the effect of the clash between the sobriety of Pasolini's approach to content matter and the intense, even chaotic affectivity of the filmic techniques he mobilised. These techniques make of the figure of Christ the same 'envoy from outside' that Deleuze recognised in the stranger (Terence Stamp) of *Teorema*: the 'living problem [...] towards which everything converges, as towards the always extrinsic point of thought, the uncertain point, the leitmotif of the film: "I am haunted by a question to which I cannot reply"'.[52] For Deleuze, far from restoring to thought the internal certainty that it lacks, this uncertain point brings the unthought into thought, defying any epistemology:

> Thought finds itself taken over by the exteriority of a 'belief', outside any interiority of a mode of knowledge. Was this Pasolini's way of still being Catholic? Was it on the contrary his way of being a radical atheist? Has he not, like Nietzsche, torn belief from every faith in order to give it back to rigorous thought?[53]

51 Lisa Åkervall, 'Cinema, Affect and Vision', *Rhizomes*, 16 (Summer 2008), <http://www.rhizomes.net/issue16/akervall.html> [accessed 14 August 2015].

52 *Time-Image*, p. 174.

53 *Time-Image*, p. 174.

How does Deleuze's question, which he asked in relation to *Teorema*, find a retrospective answer through the lens of *Il Vangelo secondo Matteo*'s filmic sublime? How did Pasolini tear belief from every faith here, in order to give it back to rigorous thought? In order to answer this question, let us return for a moment to Gordon's already cited observation on 'the primary and absolute importance assigned in [Pasolini's] value system to selfhood and to the potentially overwhelming expressivity of the self and his desires': we can trace the same overwhelming expressivity in the representational approach to the figure of Christ in *Il Vangelo secondo Matteo*. This figure is a living problem in so much as it tears belief from faith. The paradoxical combination of order and chaos that I have highlighted in the film, and that is catalysed by Christ, was also firmly at the centre of Pasolini's preparatory documentary of location scouting, *Sopralluoghi in Palestina per il Vangelo secondo Matteo* (1965). As I have argued elsewhere, in the documentary Pasolini created a self-portrait of the artist as a man shaped by intellectual restlessness, anxiety, and mental disorder; he did so by comparing and contrasting himself to the impressive order, clarity, and calm that he associated with Don Andrea, the priest who accompanied him in his journey.[54] It is fair to say that Pasolini saw Don Andrea as a lucid and serene representative of the 'most advanced forces of Italian Catholicism', to cite his words again, and himself as a restless Marxist intellectual. In the light of these observations, it is possible to see the Christ of *Il Vangelo secondo Matteo* as the synthesis of the two personalities of Pasolini and Don Andrea, as portrayed in *Sopralluoghi in Palestina per il Vangelo secondo Matteo* — resulting in a paradoxical combination of order and disorder, clarity and chaos, orthodoxy and heresy, religiousness and laicism, which mirrors the film's own paradoxical mix of supernal sacrality and historical materialism, of a news-like *cinéma vérité* style and expressionist techniques, of sacred and world music, of abstraction (the barren landscapes, the hollow spaces) and naturalism (the poor homes of Southern Italy that are the film's setting, the simple tools and gestures of farmers and fishermen, the proletarian non-actors). Indeed, however autobiographical, Pasolini's Christ is much more than a figure of an organic intellectual

54 Laura Rascaroli, *The Personal Camera: Subjective Cinema and the Essay Film* (London: Wallflower/Columbia University Press, 2009), pp. 158-69.

violently protesting against iniquity and the degeneration of society in neocapitalist times. He is at least as much Christian as he is Marxist, as much divine as he is human; and the coexistence of such opposites creates an effect that is rather arresting, and certainly excessive. As Pasolini years later remarked about his film, '[i]t's not a practicing Catholic's work, it seems to me an unpleasant and terrifying work, at certain points outright ambiguous and disconcerting, particularly the figure of Christ'.[55] There is something in the film that exceeds the ostensible reticence, soberness, good taste, and orthodoxy highlighted by some critics, and by the Church itself at the time of its release. In Jean-Luc Nancy's words, what emerges from Pasolini's cinema is 'an extraordinary openness to practising a different way of art [...] or, more importantly, a different way of making sense, opening himself to a different way of sense'.[56] What I have called the immanent sublime of *Il Vangelo secondo Matteo* stems not from faith — from the miracles, or the most transcendental moments of the Gospel's story — but from a belief torn from faith and given back to rigorous thought; this is a filmic affect that inscribes the unthought into thought and that sabotages any one-dimensional reading of the film to 'open up abysses of different dimensions'.[57]

Acknowledgments

I wish to thank Jill Murphy for her contribution to the background research for this essay, and our stimulating conversations on the Passion iconography in Pasolini, Godard and beyond; and Roberto Cavallini, for his insightful and productive feedback on the first draft of this chapter.

55 *Pasolini on Pasolini*, p. 77.

56 Jean-Luc Nancy, 'The Sacred World', European Graduate School Lecture, 2010, <http://www.egs.edu/faculty/jean-luc-nancy/videos/sacred-world/> [accessed 23 August 2015].

57 My translation. Pasolini cited in Maria A. Macciocchi, 'Cristo e il marxismo', *l'Unità*, 22 December 1964, p. 3.

Il Vangelo secondo Matteo, Pier Paolo Pasolini, 1964

FABIO VIGHI

BELIEF AS FETISH
The religion of capitalism in Elio Petri's cinema

> One can behold in capitalism a religion, that is to say,
> capitalism essentially serves to satisfy the same worries, anguish,
> and disquiet formerly answered by so-called religion.
>
> Walter Benjamin

> For we must make no mistake about ourselves: we are as much
> automaton as mind.
>
> Blaise Pascal

'God is unconscious'

The argument that Elio Petri's cinema reflects the views of an atheist is akin to what the French call a *vérité de lapalisse*, an obvious, somewhat banal and even amusing truth. There is indeed little doubt that Petri's aversion to religion – particularly Catholicism – transpires in most of his films and contributes to what is often referred to as their leftist political commitment. However, the question raised by atheism is much more complex than its definition. My exploration of Petri's cinema rests on the psychoanalytic claim that what is commonly known as atheism does not liquidate belief, but paradoxically strengthens it by disavowing its unconscious roots. In this respect, it is worth recalling that, if Sigmund Freud dispensed with religions tout court as expressions of 'mass-delusions', Jacques Lacan went a step further when he said, in *Seminar XI*, that "the true formula

of atheism is not God is dead [...] the true formula of atheism is God is unconscious". Lacan's point is that we broach atheism – and as a discipline, psychoanalysis certainly strives toward it – not when we proudly proclaim the death of God, but when we realise that belief is constitutive of the structure of signification per se, insofar as it inscribes itself in those gaping holes produced by language and the divisions (alienation) it establishes. Belief therefore appears as the inevitable result of the subject's (at least minimally traumatic) encounter with the inconsistencies in the order of meaning embodied in symptoms and unconscious significations.[1] If this is the case, then true belief operates "underground", behind one's back. As Lacan would put it, the conscious subject of the statement ("I am an atheist") is by definition *foutu* (or, to use a less vulgar term, "undermined") by the unconscious subject of the enunciation ("I say that I'm an atheist, but unconsciously I believe in...").[2] In this respect, psychoanalytic treatment aims to "disturb" the structuring function of unconscious beliefs, since only such endeavour to interfere with the subject's disavowed libidinal attachments offers the chance of a radical recalibration of one's psychic economy. The meaning of atheism is therefore fully uncovered only when the subject experiences the failure of the signifier that unconsciously sustains their identity and worldview.

It is well known that Elio Petri enjoyed a profound grasp of Freudian psychoanalysis, whose influence on his cinema is self-evident. If this influence means anything, it means that Petri was aware of the basic psychoanalytic axiom that the unconscious "runs the show", relentlessly disrupting every subjective utterance and, consequently, any ideological/political stance that the subject might express or wish to articulate. I claim that this awareness is the overriding cipher of Petri's cinema, manifesting itself in a number of variations on the theme of neurosis. In fact, if Petri's subject gives voice to the author's unremitting

1 Apart from Slavoj Žižek's work, which often reflects on belief and the meaning of atheism, see also McGowan, 2010.

2 On the difference between statement (enunciated) and enunciation, see particularly Jacques Lacan, *Écrits* (Paris: Seuil, 1966). Trans. Bruce Fink, in collaboration with Héloïse Fink and Russell Grigg (New York: W.W. Norton, 2006), pp. 671-702.

political engagement, such engagement is strictly correlated to the representation of the subject's painful struggle with their own psychic inconsistencies, summarised by Freud (1894 and 1927) with the term *Spaltung* (splitting). Freud's *Spaltung* indicates precisely that the supposed unity and self-transparency of the subject (its self-consciousness) is nothing but a pious illusion in the face of the inerasable fracture that embodies the contradiction between consciousness and the cryptic messages radiating from the unconscious. In Lacan's work, this contradiction gives body to what is generally known as *castration*. To say that the subject is by definition castrated means that its existence is characterised from start to end by an inner conflict with the inaccessible signification of the unconscious, which is cut off from the meanings progressively elaborated at the level of self-consciousness. Being inhabited and indeed ruled by unconscious formations that are resistant to subjectivation is not only the curse of any subjective identity, but also its condition of possibility, since language, sense and communication are conceivable only against the backdrop of their fundamental failure.

It seems to me that the failure of subjectivity as characterised by its splitting is of decisive theoretical relevance if we are to make sense of Petri's *political* cinema, including the meaning and consequence of the atheism it strives to embrace. I therefore argue that the aim of Petri's work can be appreciated by paying close attention to those cinematic instances where the alienated subject is, as it were, "presented the bill" for their unconscious attachments, which constitute the last defensive barrier against castration. In this respect, belief and castration are two sides of the same coin, since in its most resilient (i.e. unconscious) configuration, belief is the subject's answer to the encounter with the castrating lack that subtends the signifying chain. Forcing the subject to face castration would appear to be the central, even obsessive concern for Petri, whose cinema is characterised by an irredeemable tension between the unconscious, and therefore automatic dimension of belief (in a given set of socially-binding meanings) and the shattering awareness of the lack of foundations of such belief. At some point, Petri's key characters fall out of their socio-symbolic order, experiencing the inconsistencies of the values around which their identities

are structured. The centrality of this tension is condensed in the following statement from Petri:

> To give values, aims, ends, meanings to things is a stratagem through which we aim to forget what we call "death" and "time" – it is a trick contrived in perfectly bad faith. The first division inside us is about the remembering or forgetting of death and time. [...] we all act, more or less systematically, so as to almost completely repress the notions of death and time.

'*Un pezzo, un culo!*', or: are we atheists yet?

It may seem inappropriate to speak about religion in relation to Petri's controversial *La classe operaia va in paradiso* (1971), a film on the alienation of the post-1968 factory worker caught between two leftist ideological perspectives, or "promises of redemption": the Marxist-Leninist push to radicalise social conflict, and the trade union's reformist agenda. However, what is at stake for the film's protagonist, Ludovico (Lulù) Massa (Gian Maria Volontè), is precisely the resilience of his belief. If the revolutionary students fail in their attempt at radicalising Lulù – and, symbolically, the Italian working class – it is because they are blind to the concrete function of belief within the factory, which the film presents as a cunning yet irresistible form of libidinal attachment that defies conscious reflection. Structurally, Lulù's visceral attachment to factory work (his symbiotic relationship with the machine), and consequently to the capitalist mode of production, can be classed as a *religious* category inasmuch as it "plugs the hole" in the capitalist structure of signification, allowing him to retain a minimum of sanity in the alienating workplace.

The theme of the fetishistic eroticisation of modern (Fordist) factory work comes to the fore with particular insightfulness in the sequence where Lulù describes, in one of his typical rants, his ability to focus on his assembly-line job, which results in high productivity (his task is to operate a machinery that produces metal pieces for unspecified use). 'È semplice, io penso al culo dell'Adalgisa: un pezzo, un culo; un pezzo, un culo; un pezzo, un culo...' (It's simple, I think of Adalgisa's arse: one piece, one

arse; one piece, one arse; one piece, one arse...). In this vulgar yet revealing passage, Petri succeeds in showing how the libidinal grip of capitalist ideology does not pertain only to the sphere of consumption, as with Marx's notion of "commodity fetishism"; it also, crucially, concerns the productive sphere, more precisely the bodily materiality of work itself. Here the obvious fetish – Lulù's co-worker Adalgisa's derriere – epitomizes the libidinal connection with work that prevents Lulù from fully subjectivising the absurdity of his condition: the repetitive, mind-numbing activity required of him as a metalworker is fetishized as a last-ditch, perverse defence mechanism against potentially self-destructive existential anguish.

Lulù's subjectivity is therefore split between (conscious) knowledge and (unconscious) belief. From the initial sequences through to his encounter with the revolutionary students, it is apparent that he knows that he is being exploited, and that, as a consequence of his dehumanising job, his life is alienated to an unbearable degree, down to the threat of sexual impotence. However, the film suggests that one does not understand the plight of the working class if one omits from socio-political analyses the question of the workers' unconscious attachment to their alienation. As the opening scene unequivocally indicates, Lulù perceives his libido as redirected from the bedroom to the factory: his inability to respond to his partner's sexual desire is explained by way of a reference to the affinity of the human body and the machine; essentially, as he claims, 'l'individuo è uguale alla fabbrica', adding an explicit 'fabbrica di merda!' (The subject is identical to the factory – producing shit / shitty factory). The point to emphasise here is that Lulù's partly disavowed attachment to the factory embodies nothing other than the elementary degree of belief that he needs in order to continue to sustain his identity as a metalworker. We are referring to the category of disavowal (*Verleugnung*) that for Freud first, and then for Lacan, characterises the structural position of perversion. The pervert, in other words, knows that the Other (here, capitalism as a system of social reproduction) is weak and "lacking", and yet he disavows that knowledge by offering himself up as the abject object of the Other's libido – i.e. by plugging up the Other's lack and restoring it as a fully-consistent entity. The merit of the film

lies in bringing Lulù face-to-face with his existentially necessary yet disavowed, automated, "machinic" belief, which operates at a much more fundamental level than the explicit ideological texts (Marxism-Leninism and unionist reformism) that 1970s Italian factory workers have at their disposal in their bid to improve their condition. Indeed, only by experiencing the inherently traumatic senselessness of his perverse attachment to work, the film seems to suggest, can the worker intercept the possibility of change.

Subjective disconnect, however, is objectively neutralised and recalibrated by the ideological efficacy of capitalist relations. The social tragedy described by Petri originates in the ubiquitous strength of capitalist ideology and consequent absence of alternative forms of belief. This is enough to preclude any radical shift in the worker's psychic economy, no matter how deeply he is "neuroticised", thus becoming aware of the ruse that sustains his social role and identity. Even when, after losing a finger in a work-related accident, Lulù suddenly decides to embrace the revolutionary cause of the students, morphing into an inspirational leader for the angry protesters, his conscious belief in the anti-capitalist agenda remains rooted in the unconscious identification with hyper-productive, abstract factory work, which is why at the end of the film we find him back on the assembly-line. The point is that despite being confronted with the absurdity of his attachment to the alienating routine of the factory, Lulù remains a believer in the capitalist religion of wage work, which is precisely where the entire game (social conflict) is ultimately played out according to Petri. Thus, the film seems to tell us that as a prerequisite to become an atheist under capitalist conditions – i.e. to stop believing in capital and its tentacular, de-territorializing categories – one would have to disengage from the capitalist "belief before belief",[3] in our case the perverse libidinal investment in work and the obdurate masochistic fantasy therein nestled, insofar as the modern subject's fundamental social mediator is abstract work. Put

3 This expression is used by Slavoj Žižek to indicate how conscious belief is by definition structured around some unconscious forms of "passionate attachment". Žižek first used this turn of phrase in relation to Blaise Pascal's famous wager (see Žižek 1989: 40).

differently, Petri's critique coalesces around the insight that no
other form of identification is available (at least for the working
class) outside the "work society". The totality of human life is
mediated by the abstraction called wage labour.

The critique of modern work as an alienating yet unconsciously
binding category is already articulated with painstaking precision
in another masterpiece by Petri, his second film *I giorni contati*
(1962). The film's protagonist, Cesare Conversi (Salvo Randone),
is a middle-aged "stagnaro" ("plumber" in Roman dialect) who
decides to quit his life-long profession after seeing a man of his
age die of heart attack on a bus (a traumatic moment comparable
to Lulù's loss of a finger in *La classe operaia*).[4] When the film was
released, Petri summed up its aim with this simple yet insightful
declaration: "it is a protest against the obsession of modern life:
everyone is busy, worrying, in a hurry to get… where? To a sad old
age full of regrets for what one has sacrificed and lost". As later
replicated in the narrative trajectory of *La classe operaia*, Cesare's
"revolutionary" decision to unplug from the capitalist matrix –
here also symbolised by the injunction to work – does not lead
to subjective regeneration. Instead, after running out of money
and flirting with the criminal underworld of Rome, Cesare (in a
narrative twist that, despite the different social milieu, reminds
us of "Accattone"'s fate in Pasolini's eponymous 1961 film)
realises that he is left with no other option but return to his old
job.[5] Ironically, a few days later he dies during a bus journey, in

4 The character of Cesare was inspired by Petri's own father, who left his
 job at the age of 50 (in Rossi 1979: 38).
5 Although Accattone's path is the obverse of Cesare's (he goes from
 unemployment/crime to work and back to unemployment/crime), he
 nevertheless embodies, like Cesare, the fundamental deadlock of the
 modern "work society": any alternative to the belief in the dogma of wage
 work and consumerism is destined to fail. Incidentally, Petri confesses
 his debt to Pasolini at a very significant moment in *I giorni contati*, when
 the newspaper used to cover the unknown man's face after his death on
 the bus reveals the title of a piece on Pasolini ('Come Pasolini concilia
 cinema e letteratura', 'How Pasolini reconciles cinema and literature').
 From my perspective, the most obvious overlap between Petri and Pasolini
 concerns the angst-ridden questioning of the possibility of suspending
 one's (unconscious) belief in capitalism.

a similar manner to the unknown man whose heart attack had triggered his initial decision to leave his job.

While Petri's cinema seems to voice a kind of cosmic pessimism that leaves no room for direct political intervention (a "no exit" scenario reminiscent of Pasolini or, where more grotesquely fashioned, the cinema of Rainer Werner Fassbinder), I would rather read it through what Slavoj Žižek has called 'the courage of hopelessness', a phrase that extols the intrinsic political consequence of the atheistic resolution to confront and tarry with the ultimate senselessness of human existence, *inclusive of one's unconscious beliefs*. Such resolution is politically relevant on account of the critique it levels against a social framework whose ideological pervasiveness appears to pre-empt any sustainable or revolutionary defection, whether individual or collective: once the modern subject "drops out" of the capitalist matrix, Petri seems to suggest, they are left with no other choice but "rebound back" into the folds of that very matrix and its libidinally-charged rituals. Following Benjamin's precious intuition, the non-dogmatic, cultic rituals that unassumingly buttress the symbolic fabric of our capitalist universe should be regarded as profoundly religious precisely because they hook people's beliefs in a world structured around the incessant, totalising production and consumption of exchange values.

Mind the gap: belief as fetishism

Another way of putting this is by claiming that Petri's cinema is obsessively focussed on the subject's rebellious yet failed attempt at disengaging from the fetishistic, at least partly disavowed roots of their belief in modern capitalist society and its political institutions. Particularly compelling is Petri's use of fetishism as the ruse through which the perverse subject circumvents castration: as Freud claimed in his groundbreaking study, the object-fetish is both worshipped and despised by the fetishist insofar as it embodies his triumph over castration while also constantly reminding him of failure, namely the obdurate persistence of castration itself (Freud 1927). Insofar as the fetish is the object that allows the pervert to obfuscate the structural

lack pertaining to and sabotaging signification, then there is little doubt that Petri's films are deeply concerned with fetishism.

Perhaps the most obvious example of the relevance of fetishism comes from the third film in Petri's "trilogy of neurosis", the grotesque and apocalyptic *La proprietà non è più un furto* (1973). As with *La classe operaia*, we witness the attempted leap from (capitalist) perversion to neurosis, as we follow vicissitudes of a "fetishist" who, at some point in his young life, happens to withdraw from the seemingly natural flow of his existence under capitalist conditions. Here it is apparent that the cause of the subject's loss of identity, which shakes him out of his routine as a bank clerk, is a form of neurosis bordering on psychosis. In brief, what becomes a problem for Total (Flavio Bucci), pushing him into the "totalising" path ruled by the death-drive, is money qua fetish. His physical allergy to banknotes is already highlighted at the start of the film. It manifests itself as a grotesquely unbearable itch, which soon leads him to resign from his job and embrace an underground existence where theft, as well as the affiliation to an imaginary movement sarcastically labelled "Marxism-mandrakism", provides the measure of the character's desperate (and, ultimately, unsuccessful) attempt to hold on to a minimum of sense outside the symbolic horizon delineated by the ideological powerhouse of capitalist relations.

Total's new yet insubstantial identity coalesces around his compulsive hatred for a wealthy and nameless butcher (Ugo Tognazzi), who he had first met in the bank where he was employed. The obsession with stealing the loutish butcher's symbols of private property (his knife, hat and even his objectified lover Anita, played by Daria Nicolodi), so as to attempt to undermine his power, are, in truth, as ineffectual and outlandish forms of rebellion as his decision to only steal goods that he deems necessary for survival ("use-objects", as it were). The tragic dimension of this character's attempt to exit the circuit of capital provides the key to Petri's "critical courage": Total gives up his "automatic affiliation", or perverse position, in the dreadfully vulgar metaphysics of capital, and yet what he encounters beyond his socio-symbolic order is nothing but his own self-destructive rage, which in vain yearns for a degree of sublimation that would lend it political credibility. For Petri, such clash between the drive

to suspend the efficiency of capitalist ideology and the lack of authentic socio-political alternatives clearly informs the deadlock of radical subversive movements in post-1968 Italian society.

It is the same vigorous despair, absolutely impervious to sentimentalism and self-commiseration, that runs through *La classe operaia* which, because of its seemingly defeatist portrayal of the working class in a historical period of great revolutionary hope, was lambasted by much of the engaged leftist intelligentsia of the time – in the most famous episode, by French communist director Jean-Marie Straub, who when the film premiered at the "International Film Festival of Free Cinema" of Porretta Terme (Italy) took the floor and demanded that all copies of the film be immediately burnt. Retrospectively, however, Petri's vision should be vindicated as realistic in spite of its outrageously grotesque features. Far from embracing a fraudulently pessimistic view of social conflict, the film's portrayal of the hapless factory worker challenges misleading pretences about the autonomy the working class's antagonistic potential in a society dominated by ubiquitous fetishistic attachments to capitalist categories. Once again, the film's central concern is with the profoundly religious character of the worker's automatic existential belief in his productive role within the capitalist social framework. Although Lulù Massa comes close to "becoming an atheist", his defection is not only deeply traumatic but by necessity short-lived and inconsequential, for immediately after his epiphany he is sucked back into the capitalist matrix, more due to lack of real alternatives than to ignorance or cowardice.

In this respect, one of the most intense sequences is the one depicting Lulù alone in his flat, after losing his job and being abandoned by everyone, including his comrades and his partner Lidia (Mariangela Melato). This is the epiphanic moment of radical subjective emptying, where everything, in theory, seems possible precisely because separation from the dominant ideological order has been achieved. The sequence is particularly effective as it shows Lulù suddenly becoming aware of the utter meaninglessness of the commodity microcosm that surrounds him. For the first time he seems truly to awaken to the fetishistic character of the commodity, as he paces up and down the flat venting his anger at futile gadgets and their producers. Of

obvious symbolic relevance is, particularly, Lulù's tussle with an inflatable Scrooge McDuck toy, presumably belonging to Arturo (his partner's son from a previous relationship). The inflatable toy, which clearly stands for capital, appears also in the film's initial sequence, where it already acts as the target of Lulù's angry gaze. The day after this revealing scene, Lulù's partner and son find him lying on the sofa wrapped in cellophane, and fear he might be dead. Although he is only asleep, the lugubrious image speaks for the state of symbolic death that has befallen Lulù: the sequence suggests that the film's hero has reached the "ground zero" of his identity, having painfully, and unwittingly, gained a distance not only from his perverse self-instrumentalisation in the capitalist "work society" and its consumerist ethos, but also from the social force supposed to antagonise such social model (the student-worker movement). However, as anticipated, what follows this potential turning point suggests that no radical subjective "redemption" is available to the 1970s factory worker; rather, what awaits any instance of radical disengagement is reintegration, as Lulù soon after accepts the help of the trade unions who get him back into his job.

Far from merely staging the vicissitudes of an unlikely post-1968 Italian worker, or pedalling a resigned reformist vision, Petri denounces the totalitarian dimension of capitalist ideology inasmuch as it penetrates and taps into the unconscious libidinal attachments of the forces supposed to antagonise it. Foreseeing that no socio-political palingenesis is in sight in 1970s Italy, Petri's film, and his oeuvre as a whole, targets a crucial aspect concerning social rebellion that was largely ignored by radical leftist movements of the time, namely the complex, contradictory, profoundly neurotic relationship that links the forces of production to the disavowed appeal of capitalist ideology. What emerges is a picture where capitalism *as a religion* grabs the worker fetishistically, thus a priori disabling, or at least sabotaging, any potentially viable attempt at conceptualising an alternative framework. From the inception of *La classe operaia* we are presented with a subject, Lulù, who knows what is wrong with his world (alienation in the factory, production of useless commodities and so on) and yet is irresistibly attached to the fundamental category of that world itself: abstract (valorised) work.

This contradictory status whereby the (cynical) subject knows full well that what he is doing is wrong, and yet keeps doing it, sums up the degree of fetishistic disavowal that animates most of Petri's heroes, including the nameless Inspector of *Indagine su un cittadino al di sopra di ogni sospetto* (1970) and the President in *Todo Modo* (1976), both played by Gian Maria Volontè. The fact that in both films the subject in question does not represent the (supposedly) antagonistic class but rather power, or the status quo, demonstrates the extent to which the concept of disavowal is central to Petri's poetics and understanding of human nature. In both cases the main character's trajectory can be regarded as structurally identical to Lulù's, insofar as what is at stake is their loss of identity, which potentially leads to subjective regeneration. *Indagine* deals with a neuroticised police inspector who suddenly realises that, essentially, he does not know what he wants: on the one hand he desires to reveal his own heinous crime (the killing of a prostitute during a perverse ritual), but on the other he fears losing his authoritarian identity and role as a powerful representative of the status quo. In *Todo Modo*, a similar clash between an unconscious desire to defect from a corrupt political institution and the attachment to one's identification with such institution is subtly portrayed as the main neurotic feature of the President – a caustic replica of DC (Democrazia Cristiana) President Aldo Moro, who only two year later will be kidnapped and assassinated by the Red Brigades.

More explicitly than other films by Petri, *Todo Modo* demonstrates the strength and depth of the connection between belief and ideology by staging a closed microcosm entirely over-determined by the political opportunism of the DC at a historical time (the mid-1970s) when the long-standing hegemony of the Party seemed under threat. What makes *Todo Modo* symptomatic of Petri's aim is the emphasis on belief as a fundamentally fetishistic feature that exceeds the religious (Christian) dimension and instead operates as an unreflective and ultimately self-destructive form of attachment – in this case to power. Crucial here is the role of don Gaetano (Marcello Mastroianni), the inexorable priest who hosts the "spiritual meetings" of the DC members in an isolated retreat, demanding their contrition and 'la restituzione del maltolto' (the return of the loot). What he stands for is that

of signalling the gap between belief and "belief before belief", in other words the failure of the religious ideology in the face of unconscious attachments. Don Gaetano's relationship with the President, whose role is to mediate the transformation of the Party in a period of crisis, progressively deteriorates, until the priest's mysterious assassination. The implication here is that the religious text is powerless, in fact annoying and cumbersome, vis-à-vis the obdurate *"jouissance"* (in the Lacanian sense of an unstoppable, self-damaging libidinal attachment) that captures the essence of the Christian Democrats' fetishistic relation to power. The President (Moro) is no doubt the emblem of the opportunistic attitude of 'trasformismo' (holding on to power at any cost by forming coalitions with different ideological currents and political actors) that Petri sees as rooted in the unconscious of the dominant political class of the time.

Petri's "hopelessness" in *Todo Modo* suggests that the possibility of a break with this most binding of beliefs is relegated to an apocalyptic vision of self-annihilation: the film ends with the President walking past heaps of dead bodies just before being himself executed by his chauffeur (played by Franco Citti, another Pasolinian marker in Petri's cinema). With such a sinister film, released only a year after Pasolini's *Salò, or the 120 Days of Sodom* (1975),[6] Petri denounces the unbreakable, totalitarian dimension of "belief" that – irrespective of Christian values – plagued the hegemonic class in 1970s Italy,[7] a decade characterised by socio-economic crisis, widespread corruption, political terrorism and the strategy of tension pursued by the Italian secret services. At the same time, the film predicts that such perverse attachment to power, which prevents change, inevitably leads to self-destruction – and only then to potential regeneration.

6 Like Pasolini's *Salò*, Petri's *Todo Modo*, together with his previous *La proprietà non è più un furto* (1973), stand for a type of cinema openly defined by the director as 'repulsive' (Petri 2012: 226). For an insightful reflection on Petri's political commitment in *Todo Modo* see Rugo (2015).

7 Hence Petri's polemical the reference to Saint Ignatius of Loyola's admonition 'Todo modo para buscar la voluntad divina' (Look in every possible way for divine will).

The wall inside

In respect of the above reading, perhaps the image that best renders the depth and lucidity of Petri's critical vision is the one narrativised in Lulù's dream about an enigmatic wall in *La class operaia*. The Kafkaesque image of the wall makes its first appearance in one of Lulù's visits to his friend Militina (Salvo Randone), an old revolutionary worker now confined to a lunatic asylum. At one point Militina starts hitting one of the walls in the asylum's courtyard repeating "Giù il muro... giù il muro" (Let's bring the wall down), a phrase that disturbs and perplexes Lulù. Then at the end of the film we see Lulù back at his job, attempting to describe the content of a dream to his co-workers, though his words are eventually drown in the deafening noise of the factory and become inaudible. The dream is about the tearing down of a wall that separates the workers from what would appear to be Heaven (hence the film's title). When they finally manage to bring the wall down, however, what the workers encounter on the other side is themselves immersed (lost) in a thick fog. Metaphorically, the wall would seem to embody the workers' class struggle against the capitalist universe. At the same time, however, Petri's film tells us that the latter cannot be separated from a conflict that is primarily constitutive of subjectivity and independent of class. What then is at stake in the image of the wall, whose demolition does not yield any immediate change but throws the subject into further confusion, is effectively what the film is about: the issue of class struggle is meaningless unless we take into consideration the antagonistic subject's disavowed (perverse) belief in the antagonised social structure. Or else, to quote Petri's lapidary explanation, "the problem of socialism is inside us".

Put differently, Petri complicates the 1970s Marxist debate on the workers' class struggle by adding a crucial reflection on the subjective category of belief qua disavowed attachment to the objective and totalising category of abstract work. More to the point, the focus of Lulù's dream would seem to be a warning against the hypostatisation of the workers' revolutionary stance in a context entirely dominated by capitalist categories that reach into the unconscious of the productive forces: for Petri, the link between 1970s working class and revolution clearly amounts to

an illusion. A less negative interpretation would still emphasise a stalemate. Even if the workers managed to vindicate the deepest stakes of their antagonistic spirit, breaking down their unconscious solidarity with what they consciously oppose, what they would find on the other side is, to quote Žižek's Lacanian reading of a well-known line from *The Matrix* (1999), "the desert of the Real": not a life of plenitude, or qualitatively different social relations, but the empty framework of subjectivity awaiting new contents, and yet immediately claimed back by the all-pervasive ideology of capital (as Lulù himself painfully discovers).

The dream of the wall is reminiscent of Hegel's famous dialectical (and highly cinematic) speculation, in the *Phenomenology of Spirit,* about the truth supposedly hidden behind the curtain of appearances: when the subject finally manages to get to this hidden truth, what he actually encounters is the distilled core of appearance, which Hegel defines as "appearance qua appearance". Here is Žižek's comment on Hegel's passage:

> The appearance implies that there is something behind it which appears through it; it conceals a truth and by the same gesture gives a foreboding thereof; it simultaneously hides and reveals the essence behind the curtain. But what is hidden behind the phenomenal appearance? Precisely the fact that there is nothing to hide. What is concealed is that the very act of concealing conceals nothing. [...] The illusion that there is something hidden behind the curtain is thus a reflexive one: what is hidden behind the curtain is the possibility of this very illusion – behind the curtain is the fact that the subject thinks something must be behind it.

With the image of the wall, then, Petri seems to suggest that beyond the alienating character of capitalist relations there is simply alienation itself – the form of alienation – as the constitutive element of subjectivity. Becoming aware of this gap separating socially-determined alienation from the ontological division of the subject is perhaps the true political lesson of Petri's film and work as a whole: no social progress is achievable without taking account of the fundamental inconsistencies that underlie the subject's relation with their

society, inclusive of the forms of unreflective attachment that unconsciously cement such relation.

In this essay I have argued that "the political" for Petri is definable only via the endorsement of the primacy of inward (subjective) over outward (objective) conflictuality. The former, however, is not meant to idealistically liquidate or delegitimize the latter (the importance or urgency of direct political intervention). Rather, it suggests that a reflection on subjective categories should be the necessary presupposition for any critical engagement with "objective conditions" of oppression. Petri's so called "politically committed" films, in other words, are able to express militancy only insofar as they delve into the abyssal, ultimately ontological crisis of the subject, whose alienation is constitutive of subjectivity itself in its dialectical relation with the social. Through the notion of belief, in its fetishistic (partially disavowed) structure, I have argued that Petri's cinema courageously embraces the constitutive contradiction, or meaninglessness, of the human condition, while at the same time mapping such notion against historically-specific forms of alienation. If we observe closely the central characters in Petri's films, it becomes clear that they are meant to represent, primarily, the alienation of humanity tout court: being human for Petri means being fundamentally out of joint, traversed by a surplus of sense that obstinately defies subjectivation. For this reason his finest characters are neurotics, constantly at war with themselves, questioning their own identity and desires while facing the threat of the other's fascinating and mysterious presence. In Petri, alienation and neurosis go hand in hand in defining the structure of the only possible definition of normality. Only from this acknowledgment does it make sense for him to engage with the critical analysis of the objective conditions of domination in a society overwhelmed by the religious passion of capitalist relations.

References

Benjamin, Walter, 'Capitalism as Religion', in Eduardo Mendieta (Ed.) *The Frankfurt School on Religion* (New York: Routledge, 2005), pp. 259-62.

Freud, Sigmund (1894), 'The Neuro-Psychoses of Defence', *Standard Edition* (London: Vintage, 2001), 3, pp. 45-61.

— (1927) 'Fetishism', *Standard Edition* (London: Vintage, 2001), 21, pp. 152-58.

— (1962) *Civilization and its Discontents* (New York: W. W. Norton, 1962).

Hegel, Georg Wilhelm Friedrich, *The Phenomenology of Spirit* (Oxford: Oxford University Press, 1977).

Lacan, Jacques, *Écrits* (Paris: Seuil, 1966). Trans. Bruce Fink, in collaboration with Héloïse Fink and Russell Grigg (New York: W.W. Norton, 2006).

Lacan, Jacques, *The Seminar of Jacques Lacan, Book XI: The Four Fundamental Concepts of Psychoanalysis* (New York: W. W. Norton, 1998).

McGowan, Todd, 'The Necessity of Belief, Or, the Trouble with Atheism', in *The International Journal of Žižek Studies* 4(2); 2010.

Pascal, Blaise, *Pensées* (London: Penguin, 1995).

Petri, Elio, 'Rubrica: da oggi in prima visione', in *Stampa Sera*, 141, 15 giugno 1962.

Petri, Elio,'Eliopensiero. Breve Antologia di Citazioni', in *L'ultima trovata. Trent'anni di cinema senza Elio Petri*, edited by D. Mondella (Bologna: Pendragon, 2012), pp. 223-34.

Rossi, Alfredo, *Elio Petri* (Milan: Il Castoro, 1979).

Rugo, Daniele, 'The pedagogy of political film. Elio Petri's *Todo Modo*', *Studies in European Cinema*, 12(2), 2015: 106-17.

Žižek, Slavoj, *The Sublime Object of Ideology* (New York and London: Verso, 1989).

Žižek, Slavoj, *Welcome to the Desert of the Real* (New York and London: Verso, 2002).

Žižek, Slavoj, 'Slavoj Žižek on Greece: the courage of hopelessness', in *New Statesman*, 20 July 2015. Available at http://www.newstatesman.com/world-affairs/2015/07/slavoj-i-ek-greece-courage-hopelessness [accessed on 28 July 2015].

RELIGION IN ITALIAN
POPULAR CINEMA

ROBERTO CAVALLINI

FOR A POLITICS OF COMIC IMMANENCE
Religion and power in the cinema of Pietro Germi

Introduction

The systematic manipulation of the stereotypical features of the Italian national character is a recurrent element in Italian Popular Cinema, especially in the genre of Film Comedy. The common trait that defines the paradox emerging from this successful film genre is whether the stereotypes are created and reinforced by the films themselves or whether the realistic impression of a social fact is exploited into a false and misleading representation. Whether or not we are facing a question of narration or an aesthetic hyperbole, it is interesting to note that the effect of stereotyping implies the fabrication of a political portrait of Italian society through comedy. The comic, as the tool for the critique of the status quo, became the paradigmatic and distinctive feature of a considerable portion of Italian film productions of the 1960s. As Mira Liehm accurately pointed out in her *Passion and Defiance: Italian Film from 1942 to the Present*, politics penetrated Italian comedy style particularly in the work of Pietro Germi and his 'sociocomedy of manners'.[1] The politics of Pietro Germi's cinema was a sophisticated attempt at destabilizing the stereotypes of Italian national character through the exploitation of the 'absurdities of Italian society'. In this chapter, I argue that the political attributes of Germi's cinema originate from a calibrated scrutiny of the intersections between Italian society and the Catholic imaginary as its compelling subtext. The two films by Pietro Germi taken into consideration,

1 Mira Liehm, *Passion and Defiance: Italian Film from 1942 to the Present* (Oakland: University of California Press, 1986), p. 216.

Divorzio all'italiana (Divorce Italian Style, 1961) and *Signori e Signore* (The Birds, the Bees and the Italians, 1966), had an exceptional international reception, with *Divorzio all'italiana* winning the *Prix de la meilleure comédie* (Prize for the best comedy) at the 1962 Cannes Film Festival and the *Academy Award for Best Writing, Story and Screenplay –Written Directly for the Screen* while *Signori e Signore* won the *Grand Prix* at the 1966 Cannes Film Festival. Both films provide the spectator with a clear illustration of the relationship between religion and power in post-war Italy and how this relationship was based on an efficient infiltration of the personal and collective behaviours of the Italian people of the time. The geographies and geometries of love scripted by Germi and his collaborators invite the viewers, through the reinvention of the Italian comedy as a film genre, to experience the comic as the critical renegotiation of the poised fabric of Italian society. Ultimately, the aim of this chapter is twofold: firstly, I would like to illustrate Pietro Germi's attempt, in his satirical trilogy of provincial Italian life, at presenting a reflection on the experience of religion from a culture of externality *to* a political form of power. Secondly, my aim is to critically engage with the subtle configuration of the comic as political critique; being strictly connected with the formation of several stereotypes of Italian society of the time, I will argue that the comic in Germi should be read as an immanent form of politics.

From religion as a culture of externality…

In a fascinating study on the stereotypes of Italy and the Italians through the work of Germain de Stael, Robert Casillo sets out to "extricate, whenever possible, that grain of truth that, for all their exaggeration, sometimes lies behind these stereotypes".[2] When focusing on the ways in which the Counter Reformation impacted Italian religiosity, Casillo insists on, making reference to different authors such as historian Angelo Ventura, poet Giacomo Leopardi and writer Pompeo Molmenti, how Italian Catholic

2 Robert Casillo, *The Empire of Stereotypes: Germaine de Staël and the Idea of Italy* (Basingstoke: Palgrave Macmillan, 2006), p. 83.

morality and worship was largely formal and somehow based on a 'culture of externality' and spectacle completely devoid of any virtue or spiritual necessity. In other words, Italian Catholicism was, and always has been, a social fact more than a spiritual project; it is during that particular historical moment, when the superficial exteriority entrenched in pseudo-religious behaviours became the result of a structural process to cement traditional values and conventional manners, that religion as social practice of exteriority grew to be the norm. In an interview with Gideon Bachmann, Pietro Germi explains his concerns related to the culture of externality and its implication and exasperation during the post-war period:

> Below this superficial hypocrisy, which tends to consolidate the external status quo, we definitely live in a period of crisis of faith; [...] this is the very dramatic aspect: we don't know anymore what it is that cements our collective life. We don't know anymore what keeps us united.[3]

Germi's concern points to the period between the 1950s and the 1970s as transitional years for Italian society, from a still largely agricultural population to an industrialized society; in this perspective, the 'decline of religion' and the reduction of the influence of the church can be seen in the decrease of Sunday mass participation from 69% in 1956 to 40% in 1966.[4]

The central theme of *Divorzio all'Italiana* revolves around the legal question about divorce, which in Italy was strictly related to the impact of Catholic religion on family structures and especially on how women influenced that particular decision. The Socialists' victory in 1963 and the slow weakening of Catholic women's associations regarding family laws, opened the road to change: nine

3 Adriano Aprà, Massimo Armenzoni, Patrizia Pistagnesi (eds), *Pietro Germi: Ritratto di un regista all'antica* (Parma: Pratiche Editrice, 1989), p. 14. My translation. "Ma sotto questa ipocrisia superficiale, che tende a consolidare lo status quo esteriore, certamente viviamo un periodo di crisi della fede. [...] E questo è il vero aspetto drammatico: che non sappiamo più quale genere di fede cementi la vita collettiva. Non sappiamo più cos'è che ci tiene uniti."

4 Paul Ginsborg, *A History of Contemporary Italy: Society and Politics, 1943-1988* (Basingstoke: Palgrave Macmillan, 2003), p. 245.

years after the film release, divorce became legal in 1970 with the
law 898/1970, still quite restrictive though and with a mandatory
five years period of separation.[5] The anti-divorce movement,
supported by Azione Cattolica, the majority of the Christian
Democratic Party, the MSI (right-wing party founded by former
fascists politicians) and the CEI (the Italian Bishop's permanent
assembly) proclaimed a referendum which took place in 1974
and failed miserably, with Pope Paul IV admittedly reporting that
the result was 'the end of Catholic Italy'.[6] What seems relevant to
highlight here is that Germi's *Divorzio all'Italiana*, while illustrating
this shift regarding the ways in which the compositional fabric
of Italian culture was defined, also occupies a definitive role in
showing the structural role of religion in public life. Germi, in
fact, employs the church as a pivotal place throughout the film
narrative. Germi's *Divorzio all'Italiana* frames religion as a culture of
externality through a subtle plot development. Let us first consider
how this works in the film.

Set in the imaginary small town of Agromonte in Sicily (the
actual town is Ispica, in the province of Ragusa), *Divorzio all'italiana*
employs the fictional church of San Firmino, in reality the Chiesa
Madre of San Bartolomeo (rebuilt after the earthquake in 1750,
with the interior scenes, shot inside the Duomo of San Giorgio in
Ragusa), as the symbolic space through which the plot develops.
After the initial credit scene which portrays the photograph
of the protagonist Ferdinando Cefalù called Fefè (Marcello
Mastroianni) and his wife Rosalia Cefalù (Daniela Rocca) in their
bed in a overemphasized pose, the film cuts into a train, where
Ferdinando-Fefè is travelling back to his beloved town Agromonte;
the town is introduced with fast edited images and statistical
information about inhabitants and unemployed people, with an
ironic calculation of the number of churches (approximately
24) and then the presentation of the Cefalù mansion, one of
the richest families of Agromonte. Ferdinando's voice over ends
with the first inaugural sequence of the film. Inside the church
of San Firmino, the priest is delivering the Sunday Sermon,

5 John Pollard, *Catholicism in Modern Italy: Religion, Society and Politics Since
 1861* (London & New York: Routledge, 2008), pp. 149-150.
6 *Catholicism in Modern Italy: Religion, Society and Politics Since 1861*, p. 150.

semi-suspended on the pulpit (once the place where the Roman magistrates used to administrate justice): 'Therefore, my faithful and beloved fellow citizen, I exhort you to vote for a party that is of the people and therefore democratic, and therefore respectful of our Christian faith. A party, to conclude, both democratic and Christian'. The word game is quite expected and the cut to the Sunday mass attendees introduces us to a sleepy and bored Cefalù family. Ferdinando, the first on the right, stands up and the voice-over begins once more with an accurate presentation of the family members. At the exact opposite place in the double nave of the church, on her knees praying, we find Angela, his first cousin. The decision to introduce the family during mass in church is a narrative expedient which is perfectly exploited by the cinematography of Carlo di Palma: the distance between the two lovers (Ferdinando and Angela) is demarcated by the family presence and the love journey that Ferdinando has to undertake revolves around the way in which the family becomes an arena of struggle. Thus the presentation of the family relies on a procedural preoccupation of arranging a set of relations through the semi-clinical gaze of the camera and the exchange of glances of the characters. The very foundational motifs of Germi's mise-en-scene is to place the characters within a strict geometrical and empathic *expository framing* through the reliance on a narrative technique of subtraction; in this sense, the narrative unity is anchored in a rhythm of individual encounters, where affiliation becomes a consequential procedure in order to offer not a moral perspective but a discursive stance. The church in Germi becomes a public place with firm spatial arrangements, which are traversed by the characters' gazes in a sort of enthralled comic immanence: Germi subordinates the main character's voice-over to the movement of constant peeking and glancing. Geometries of controlled passion implicitly motivate Germi's mise-en-scene inside the church, which is not based on correlation or juxtaposition but on a hierarchy of bodies and gestures. This hierarchical movement has the ability to produce a comic effect, which essentializes its materiality and transform laughter into a form of knowledge. We laugh because we know that the truth is simpler than we thought. We therefore comply with Fefè's strategies and we laugh at his tics and paroxysms because he performs the ultimate limits of social

awareness, bordering, as explained also by other commentators, into the grotesque.

Simon Critchley's philosophical enquiry on humour could be useful at this point to explain my concern with the comic as political critique. Critchley's central argument in fact claims that the redemptive or messianic power of laughter does not offer us to compensate for a potential paradisiacal beyond, but instead it shows us that we have no alternative but this world. Writes Critchley:

> The consolations of humour come from acknowledging that this is the only world and, imperfect as it is and we are, it is only here that we can make a difference. Therefore, the redemptive power of humour is not, as it is in Kierkegaard, the transition from the ethical to the religious point of view, where humour is the last stage of existential awareness before faith. Humour is not nuomenal but phenomenal, not theological but anthropological, not numinous but simply luminous.[7]

The tragic force of the comic resides in the dissolution of any beyond and the reaffirmation of a disjointed present. The luminous light(ness) that laughter delivers on our everyday life radicalizes our being in the world. We cynically laugh to the tragicomic world created by Germi because there is, simply, no alternative. This is the tragic horizon that the comic in Germi instils in our material and sensual relation to the world: by changing the impulse underlying such situation, the comic suspends any transcendental unity and radically eludes the pretension of a free subjectivity. The act of laughing, unfortunately, does not release us from our sins, projecting them in some neutral and safe space, because it makes them indignantly and immanently real.

Throughout the film, the symbolic presence of the church marks the logical continuity of the plot during at least seven crucial moments: 1) the introduction of the Cefalù family; 2) the lovers' first glance of acknowledgment happens when Angela exits the church; 3) when Fefè starts fantasising about possible incidents in order to kill Rosalia, we are introduced, on the church's stairs, to Don Ciccio Matara, local mafia killer,

7 Simon Critchley, *On Humour* (London and New York: Routledge, 2002), p. 17.

semi-suspended on the pulpit (once the place where the Roman magistrates used to administrate justice): 'Therefore, my faithful and beloved fellow citizen, I exhort you to vote for a party that is of the people and therefore democratic, and therefore respectful of our Christian faith. A party, to conclude, both democratic and Christian'. The word game is quite expected and the cut to the Sunday mass attendees introduces us to a sleepy and bored Cefalù family. Ferdinando, the first on the right, stands up and the voice-over begins once more with an accurate presentation of the family members. At the exact opposite place in the double nave of the church, on her knees praying, we find Angela, his first cousin. The decision to introduce the family during mass in church is a narrative expedient which is perfectly exploited by the cinematography of Carlo di Palma: the distance between the two lovers (Ferdinando and Angela) is demarcated by the family presence and the love journey that Ferdinando has to undertake revolves around the way in which the family becomes an arena of struggle. Thus the presentation of the family relies on a procedural preoccupation of arranging a set of relations through the semi-clinical gaze of the camera and the exchange of glances of the characters. The very foundational motifs of Germi's mise-en-scene is to place the characters within a strict geometrical and empathic *expository framing* through the reliance on a narrative technique of subtraction; in this sense, the narrative unity is anchored in a rhythm of individual encounters, where affiliation becomes a consequential procedure in order to offer not a moral perspective but a discursive stance. The church in Germi becomes a public place with firm spatial arrangements, which are traversed by the characters' gazes in a sort of enthralled comic immanence: Germi subordinates the main character's voice-over to the movement of constant peeking and glancing. Geometries of controlled passion implicitly motivate Germi's mise-en-scene inside the church, which is not based on correlation or juxtaposition but on a hierarchy of bodies and gestures. This hierarchical movement has the ability to produce a comic effect, which essentializes its materiality and transform laughter into a form of knowledge. We laugh because we know that the truth is simpler than we thought. We therefore comply with Fefè's strategies and we laugh at his tics and paroxysms because he performs the ultimate limits of social

awareness, bordering, as explained also by other commentators, into the grotesque.

Simon Critchley's philosophical enquiry on humour could be useful at this point to explain my concern with the comic as political critique. Critchley's central argument in fact claims that the redemptive or messianic power of laughter does not offer us to compensate for a potential paradisiacal beyond, but instead it shows us that we have no alternative but this world. Writes Critchley:

> The consolations of humour come from acknowledging that this is the only world and, imperfect as it is and we are, it is only here that we can make a difference. Therefore, the redemptive power of humour is not, as it is in Kierkegaard, the transition from the ethical to the religious point of view, where humour is the last stage of existential awareness before faith. Humour is not nuomenal but phenomenal, not theological but anthropological, not numinous but simply luminous.[7]

The tragic force of the comic resides in the dissolution of any beyond and the reaffirmation of a disjointed present. The luminous light(ness) that laughter delivers on our everyday life radicalizes our being in the world. We cynically laugh to the tragicomic world created by Germi because there is, simply, no alternative. This is the tragic horizon that the comic in Germi instils in our material and sensual relation to the world: by changing the impulse underlying such situation, the comic suspends any transcendental unity and radically eludes the pretension of a free subjectivity. The act of laughing, unfortunately, does not release us from our sins, projecting them in some neutral and safe space, because it makes them indignantly and immanently real.

Throughout the film, the symbolic presence of the church marks the logical continuity of the plot during at least seven crucial moments: 1) the introduction of the Cefalù family; 2) the lovers' first glance of acknowledgment happens when Angela exits the church; 3) when Fefè starts fantasising about possible incidents in order to kill Rosalia, we are introduced, on the church's stairs, to Don Ciccio Matara, local mafia killer,

7 Simon Critchley, *On Humour* (London and New York: Routledge, 2002), p. 17.

as a possible perpetrator; 4) subsequently, Fefè considers the potential lovers for her wife: one is Tonino Gambacurta, church choir member who is however a *castrato* (a male soprano, literally castrated); 5) when Fefè woke up after a drinking night by the noise of the church bells, he run out on the balcony and see Carmelino, Rosalia former lover, walking below his house (seen also by Rosalia); 6) Ferdinando follows Carmelino into the church, to discover he is the priest's adopted son and a painter, restoring the church frescoes (the cut from the church to the Cefalù's house is sudden and direct); 7) the funeral of Angela's father, who died because of an heart attack after the discovery of their love relationship, is a significant moment where the film narrative finally converges. All the main plot twists in the film are clustered around the presence of the church as the centre of societal life where every trajectory intersects: the church and its surroundings becomes the stage where public life is performed as pure theatre. Germi shapes the religious stereotypes of the Sicilian population with the concern of exploiting comedy as a realistic device. Moreover, the plot twists further play with comic immanence as a horizon of political awareness.

...*to religion as a political form of power*

The widely accepted proposition that considers Italian Catholicism, in a historical perspective, as constituted by fragmented several variations of catholic experiences each coinciding to different class lines (a catholicism of the workers, of the peasants, of the urban masses and the well-known divide between the North and the South), originates from Antonio Gramsci's reflection on the multiplicity of regional and local practices and social backgrounds and traditions.[8] Gramsci, however, notoriously indicates how the principal elements of popular common sense are constituted in the masses by the pragmatic influence of religion in everyday life. For Gramsci, the main mission of the Church (and specifically of the Jesuits), was

8　　Antonio Gramsci and David Forgacs, *The Gramsci Reader: Selected Writings 1916-1935* (New York: New York University Press, 2000), p. 344.

to create a powerful cohesion between the top and the bottom of Italian society, between the intellectuals and the masses through 'doctrinal unity'.[9] In this sense, even though local nuances and social differences in various parts of the country have been delineated by some scholars,[10] the popular strata of Italian society, especially during the post-war period, are typically controlled and shaped by the religious tradition which functions as a social organized apparatus of consensus and collective identification.

From Sicily to Veneto and throughout the peninsula, religion maintains its regional characteristics but also infiltrates the interstices of local politics. If in *Divorzio all'italiana* the church is the stage for civic life where the culture of externality is performed and where the crucial actions of the story takes place, in *Signori e Signore*, the church does not even appear in the film, only the power that is associated with it pervades every single moment of everyday life and everything is re-conducted to the institution of religion as power. In Germi, ultimately, comic immanence is a device to reduce the spectacle of everyday life to a closed system of behaviours. In *Signori e Signore*, Germi, as noted by Mario Sesti,[11] shifts the satirical critique of the limits and inefficacy of the moral codes from a subjective point of view to a collective level of behaviour whereby the hypocritical tendency of the characters, belonging to the bourgeois class, becomes a diffused social fact. In *Signori e Signore*, Germi and the scriptwriter Luciano Vincenzoni interweaves the superficial probity of the citizens of the town of Treviso with the openly deceitful masquerade of adultery and betrayal. At a discursive level, Germi delineates the aesthetic boundary of the comic towards the dissolution of religion from a culture of externality to an embedded political form of power. Religion, in *Signori e Signore*, is not even more a spectacle.

Comedy, as totally redefined by Germi starting with *Divorzio all'italiana*, becomes a sort of continuation of the spirit of Italian

9 *The Gramsci Reader: Selected Writings 1916-1935*, p. 330.
10 See Michael P Carroll, *Veiled Threats: The Logic of Popular Catholicism in Italy* (Baltimore: Johns Hopkins University Press, 1996).
11 Mario Sesti, *Tutto il cinema di Pietro Germi* (Milan: Dalai Editore, 1997), p. 253.

Neo-realism after the Second World War.[12] Pietro Germi was very much aware of such a process and how this contiguity was accepted in the film industry of the period:

> In the post-war period, cinema was in a sense emblematic: suddenly, there was almost the sense of being able to see things freely for the first time. There was the desire to look at things which we hadn't ever be able to look at. Hence the violent documentary approach of certain films. Today, inevitably, it is very difficult to find this particular feature in terms of form and content. Other perspectives have been developed: once society began to get settled, what emerged were the conditions to reach a more complex representation of a social situation, to reach fiction.[13]

Between Italian Neo-realism's impulsive reaction to the socio-political condition of Italian society and Italian Film Comedy's sophisticated form of social critique, the fate of Italian Cinema was always ensnared to the political reflection of the Italian social milieu, as it was the case with the Italian Political Cinema of Francesco Rosi and Elio Petri. In fact, the direct correlation between Italian Film Comedy and Italian political films has

12 The generic tendency of reading post-war Italian cinema through the matrix of Italian Neo-realism has been recently reassessed by different international scholars, which particularly reconsidered the transition from Italian Neo-realism to Italian Popular Cinema of the 1950s and 1960s (O'Leary and O'Rawe 2011; Bayman and Rigoletto, 2013). Moreover, as Raffaele De Berti correctly pointed out, the intermedial character of Italian film culture of the 1950s was oscillating between 'auteurial culture and popular culture' (De Berti 2000, 127), with the multiple expressions of Italian Cinema always existing in a continuous but transformative process.

13 Adriano Aprà, Massimo Armenzoni, Patrizia Pistagnesi (eds), *Pietro Germi: Ritratto di un regista all'antica* (Parma: Pratiche Editrice, 1989), p. 64. My translation. "Il cinema dell'immediato dopoguerra era in un certo senso tipico: c'era la sensazione, quasi, di poter vedere le cose per la prima volta liberamente, in modo improvviso; c'era il gusto di vedere le cose che non s'erano mai potute guardare. Di qui la violenza di senso documentaristico di certi film. Oggi, per forza, tale carattere particolare, formale e contenutistico, è molto difficile che si possa ritrovare. Si sono magari sviluppate altre cose: essendosi assestata la società, ci sono le condizioni per arrivare alla rappresentazione più complessa di una situazione sociale, al romanzo".

already been detected by Alfredo Rossi in his essential volume *Elio Petri e il Cinema Politico Italiano*. Rossi centred his reflection upon the correspondence between these two film genres through the pivotal acting figure of Gian Maria Volonté. As Rossi argued, the secret of Italian Film Comedy is that of "reorganizing, at the level of the symbolic, the premise of a social class through a physiognomy of class".[14] According to Rossi, what actors and comedians such as Alberto Sordi, Nino Manfredi and Vittorio Gassman represent (to which one could surely add Tognazzi and Mastroianni), is nothing more than *supporti d'italianità* (props of Italian-ness), in line with the tradition of the *commedia dell'arte* and figures such as Pulcinella:

> The true mask effect, and so the true essence of Pulcinella's function, is not 'counterfeiting', 'characterizing', but instead to stage a *trouble* of subjectivity. Through a mask, dead people, larva and phantasms, impersonate (*persona* in latin means mask) the object of desire: with it one undertakes the game of *absolute mimesis*. Which is, at the same time, the *tragedy of mimesis*.[15]

The dramatic and tragic aspects of Italian comedy have been generally recognized as the key factor for an investigation of the discursive character of Italian national identity. It is however worth reflecting upon Rossi's articulation of the comic through the mask effect as a *trouble* of subjectivity. Rossi seems to suggest that those props of Italian-ness conceal the subversive potential of the comic through a morphological totalization of the body; or, in other words, this trouble is what Mario Sesti defines, in the cinema of Pietro Germi, as the grotesque figuration of faces and bodies in their everyday life appearance.[16] In Germi's redefinition of Italian comedy, comic immanence as that which stages a tragic and absolute mimesis, substantially coincides with the total permutation of the real: comic immanence, therefore, is the realistic implosion of reality through laughter which, following

14 Alfredo Rossi, *Elio Petri e il Cinema Politico Italiano: La piazza carnevalizzata* (Milan/Udine: Mimesis Edizioni, 2015), p. 46.
15 *Elio Petri e il Cinema Politico Italiano: La piazza carnevalizzata*, p. 47
16 See Mario Sesti, *Tutto il cinema di Pietro Germi* (Milan: Dalai Editore, 1997), pp. 107-112.

Rossi's suggestions, configures a trouble of subjectivity. It is this configuration, I argue, that can be detected in *Signori e Signore.*

After the opening scene and the introduction of the doctor Professor Giacinto Castellan (Gigi Ballista) the young wife Noemi (Beba Loncar) and Toni Gasparini (Alberto Lionello), the three together stops by the church where Ippolita Gasparini (Olga Villi), Toni's wife, is conscientiously counting, together with other pious and affluent women, the money collected from church offerings. The priest Don Schiavon (Virgilio Scapin) announces the arrival of the happy-go-lucky brigade and notifies Ippolita, but she firmly scolds him and tell him that the counting must be terminated before anyone leaves the room. As she instructs a young assistant to tell his husband and friends to go and that they will follow them as soon as they are done, her presence at the head of the table counting money stages her as the incarnation of that form of power which, even completely devoid of religious connotation, will manifest itself in each episode of the film. Even when the culture of externality is over, what remains is just the bureaucratic administration of power within the collectivity of the petty bourgeoisie. Not a single sequence in the film shows the 'Signori and Signore' participating in a religious celebration or go the mass or perform any religious practice. Religion enters the daily life of our characters only through the power it inflicts within their everyday trajectories. Let us examine how this is constructed in the film.

The second and central episode of the film features the extra-conjugal affair between the Ragionier Osvaldo Bisigato (Gastone Moschini), afflicted by his tedious and unexciting life and young and naïve bar attendant Milena Zulian (Virna Lisi). The episode is a perfect example of transition from the personal to the political: if betrayal is perfectly allowed and even respected socially, when the couple begins to ask for more (separation), society, especially at the religious level, turns against them. The crucial character here is still Ippolita Gasparini, close friend of Bisigato's wife. She decides to manage the situation, sending Don Schiavon to persuade Bisigato of his actions, which are not conforming to the ones of a 'good Christian'. Bisigato's reply shows the typical local flavour of the Veneto province: 'Mi no so niente, mi no digo niente' ('I don't know anything, I don't say

anything', a very popular way of saying which somehow resemble the much more famous Southern Italian's code of silence called *omertà*). The following scene is constructed with a perfect sense of timing: in the moment when Osvaldo and Milena literally walk under the sun and cross the main square of the town observed by friends and passers-by, we witness a cut to the discussion at lunch, in the beautiful garden of a rich villa, between Don Schiavon, Ippolita Gasparini and husband, and the bishop; in the moment in which Osvaldo and Milena cross the invisible line after which their relationship is made public, the intervention is ready to take place. Bisigato, in fact, works for a local bank: the Banco Cattolico Euganeo (Euganeo Catholic Bank). Under these circumstances, and as an employee of such institution, he is fiercely discouraged from any behaviour that could provoke scandal or bad reputation for the religious financial institute. It is finally with a coordinated action between the police (who caught Osvaldo and Milena in the act of adultery) and the church (Don Schiavon is the one who takes care of Milena when Osvaldo is kept for one night in prison) that the two lovers are at last separated. Milena, in her final letter to Osvaldo, quoting Don Schiavon, admits: "Contro la forza, ragione non vale" (Against force, reason can't do anything). The case of the two lovers is thus closed, with Bisigato, after an attempt at committing a spectacular suicide in the public square, reunited with the wife and back to his provincial routine.

While the central episode of *Signori e Signore* emphasizes the socio-political permeation of religion in the life of the Veneto bourgeois class, the third and final one illustrates the mechanisms of protection, which that particular class implement to maintain its power relations. The final episode features the story of a charming 16 year old girl coming to shopping in town from the countryside; one by one, the group of friends, protagonists also of the previous episodes, take advantage of the girl but the next day are denounced by the girl's father for corruption of a minor. Germi's brutal critique here pushes the comic into the unacceptable behaviour of 'honest' citizens and their collective rape. The girl's story testifies to a series of growing liabilities to which the groups of friends are concerned. The tragicomic dimension here reaches its peak whereby the religious authorities, once again assisted by the rampant Ippolita, deal with the case and instruct the press to keep silent while Ippolita

transforms the scandal into a business transaction, literally buying the girl's father silence with money and a sexual intercourse. No scandal, no guilt, no responsibility.

In this essay I argued how Pietro Germi configures a shift from religion as a culture of externality to religion as a political form of power. Employing the comic as an immanent form of politics, Germi provides us with the most fascinating and pungent accounts of Italian society in Post War Italian cinema. With the dominant class, protected by the religious apparatus, defying the law, even the possibility of laughter is exhausted: with the final episode of *Signori e Signore*, Germi's vision achieves its ultimate frontier of political awareness, transforming the portray of a group of citizens into a *memento mori* of a society transfixed by the spectacle of power it represents.

References

Aprà, Adriano, Armenzoni, Massimo and Pistagnesi, Patrizia (eds), *Pietro Germi: Ritratto di un regista all'antica* (Parma: Pratiche Editrice, 1989).
Bayman, Louis and Rigoletto, Sergio (eds.), *Italian Popular Cinema* (Basingstoke: Palgrave Macmillan, 2013).
Carroll, Michael P., *Veiled Threats: The Logic of Popular Catholicism in Italy* (Baltimore: Johns Hopkins University Press, 1996).
Casillo, Robert, *The Empire of Stereotypes: Germaine de Staël and the Idea of Italy* (Basingstoke: Palgrave Macmillan, 2006).
Critchley, Simon, *On Humour* (London and New York: Routledge, 2002).
De Berti, Raffaele, *Dallo schermo alla carta: romanzi, fotoromanzi, rotocalchi cinematografici : il film e i suoi paratesti* (Milan: Vita e Pensiero, 2000).
Fournier Lanzoni, Rémi, *Comedy, Italian Style: The Golden Age of Italian Film Comedies* (London and New York: Continuum, 2008).
Gili, Jean, *Arrivano i mostri: i volti della commedia all'italiana* (Bologna: Capelli, 1980).
Ginsborg, Paul, *A History of Contemporary Italy: Society and Politics, 1943-1988* (Basingstoke: Palgrave Macmillan, 2003).
Gramsci, Antonio, and Forgacs, David, *The Gramsci Reader: Selected Writings 1916-1935* (New York: New York University Press, 2000).
Liehm, Mira, *Passion and Defiance: Italian Film from 1942 to the Present* (Oakland: University of California Press, 1986).
Pollard, John, *Catholicism in Modern Italy: Religion, Society and Politics Since 1861* (London & New York: Routledge, 2008).
O'Leary, Alan and O'Rawe, Catherine, "Against realism: on a 'certain

tendency' in Italian film Criticism", *Journal of Modern Italian Studies*, 16: 1, 2011, pp. 107-128.

Rhodes, John David, "Divorzio all'italiana / Divorce, Italian Style" in Giorgio Bertellini (ed.), *The Cinema of Italy* (London: Wallflower, 2004).

Risso, Linda and Boria, Monica, *Politics and Culture in Post-War Italy* (Newcastle: Cambridge Scholars Press, 2006).

Rossi, Alfredo, *Elio Petri e il Cinema Politico Italiano: La piazza carnevalizzata* (Milan/Udine: Mimesis Edizioni, 2015).

Sesti, Mario, *Tutto il cinema di Pietro Germi* (Milan: Dalai Editore, 1997).

Fᴇʀɴᴀɴᴅᴏ Gᴀʙʀɪᴇʟ Pᴀɢɴᴏɴɪ Bᴇʀɴs ᴀɴᴅ Jᴜᴀɴ Iɢɴᴀᴄɪᴏ Jᴜᴠᴇ́

RELIGIOUS POLITICS OF GENDER OPPRESSION IN *IL DEMONIO* (1963) AND *NON SI SEVIZIA UN PAPERINO* (1972)

Introduction

Italian horror cinema is currently meeting academic interest and critical attention.[1] Still, the examination encompasses the whole history of horror Italian cinema, so there is little written on individual films yet. In this chapter, we will focus on two horror films in order to explore the social context that led to such interesting productions, while linking it to notions of women's self-expression, secularisation and social violence. The two films taken into consideration are the neorealist horror film *Il Demonio* (The devil, Brunello Rondi, 1963), and the rural giallo *Non si sevizia un paperino* (Don't torture a duckling, Lucio Fulci, 1972). In both films, the traditional Italian southern community internalizes the Catholic oppressive religious edicts and thus women's sexual oppression occurs as a collective action executed by entire towns' population. Moreover, in both films, unruly women function as scapegoats for the town' prejudices.

In *Il demonio* (an overlooked film that prefigures William Friedkin's *The Exorcist*, 1973), Purificatione (Daliah Levi), a young peasant from South of Italy, is considered by the people's town a possessed one and a practitioner of black magic, but in fact, she is a unstable woman aching for the love of a man, Antonio (Frank Wolff). The entire village is hostile to her and blames her for everything that goes wrong within the community. Used and abused by villagers to the point of animalization, she is, actually, a victim of politics of gender and religion. As a woman in love

1 Jeffrey Sconce, *Sleaze Artists: Cinema at the Margins of Taste, Style, and Politics* (Durham, NC: Duke University Press, 2007), p. 167.

with a man who refuses to marry her, she relies on black magic to fulfill her (Catholic) role of wife. In *Non si sevizia un paperino*, Maciara (Florinda Bolkan), a troubled woman inclined to black magic, is wrongfully accused of the child murders taking place in the village, while the true culprit is a disturbed priest.

The choice of focusing on female sexuality, social oppression and witchcraft as important factors of Italy in the Sixties and Seventies is due to the historical opposition they always represented against Catholic theology and culture. If one considers that postwar Italy was also facing a strong process of secularization, the presence of irrational figures such as witches is a transgressive element opposed to Catholicism as the principal institution in Italy and they also function as critical personifications against the Church's traditional male-female division of roles, cultural conformism and sexual hierarchy. Moreover, the Catholic Church's political role has been crucial in sustaining, albeit through an uneasy collaboration, the fascist regime of Benito Mussolini.[2] In the films considered in this chapter, witchcraft functions as a metaphor for political oppression and barbaric obscurantism rather than a truly powerful practice (in fact, the magic performed by these women is truly ineffectual). *Il demonio* and *Non si sevizia un paperino* are thus excellent examples to delineate a portrait of the oppressed in Italy in terms of issues of class, religion and gender.

Il Demonio: *Ethnographic Horror*

Toward the end of the 1950s, important social changes influenced Italian economy and social life. The Cold War began to ease, and in 1950, major discoveries of natural gas and oil in the Po region,[3] together with establishment of the European Common Market, became strategic in stimulating Italy's economy. The year 1958 marked the beginning of what was called Italy's "economic miracle." Emerging from a period of serious

2 Macgregor Knox, *Mussolini Unleashed: 1939-1941. Politics and Strategy in Fascist Italy's Last War* (Cambridge: Cambridge University Press, 1982), p. 9.
3 Adams Sitney, *Vital Crises in Italian Cinema: Iconography, Stylistics, Politics* (New York: Oxford University Press, 2013), p. 200.

economic problems, the now prosperous middle class of the 1960s concentrated on searching for immediate gratification through the ethos of mass consumerism.[4] "Success, in terms of money and social prestige, was taking the place of a more intimate way of human communication based on love, understanding, and social commitment. The final outcome could only be alienation and solitude or social unrest".[5] Meanwhile, the workers' strikes and student demonstrations of the late 1960s paved the way to social unrest. Together with terrorist activities carried out by extremist groups from both the political Right and Left, Italy in the Sixties met economic recession.

In cultural terms, Italian cinema in the 1960s offered a great variety of film productions, both art films and popular films, especially the comedy-Italian-style genre and the gothic horror film. As Marga Cottino-Jones explains,

> Women are portrayed in films during this period as the typical representatives of this period of general social malaise. Furthermore, the social violence and upheaval that were starting to shake Italian society in the 1960s became the topic of several films with women ending up as victims of men's cruelty and violence.[6]

We believe that the ethnographic horror *Il Demonio* (or "pseudo-documentary"[7] as Tim Lucas brilliantly puts it) clearly fits Cottino-Jones' argument. The film's first sequence configures, with a striking economy of resources, the establishment of the theological frame that will delineates the whole story: on the one hand, the use of black magic as an ethos in opposition to Roman Catholicism and, on the other hand, the struggle of a woman which, in order to fit within the community's traditional expectations of gender, had to balance her own subjectivity and personal desires.

4 Antonio Chiesi, Alberto Martinelli and Sonia Stefanizzi, *Recent Social Trends in Italy, 1960-1995* (Québec: McGill-Queen's University Press, 1999), p. 373.
5 Marga Cottino-Jones, *Women, Desire, and Power in Italian Cinema* (New York: Palgrave MacMillan, 2010), p. 105.
6 *Women, Desire, and Power in Italian Cinema*, p. 106.
7 Tim Lucas, *Mario Bava: All the Colors of the Dark* (Cincinnati: Video Watchdog, 2007), p. 522.

The first scene presents Purificatione (nicknamed within the film as Purif) to the audiences. She is a farmer living with her parents and various brothers in a humble house in Southern Italy. In the secrecy of her bedroom, Purif pierces her breast with a sharp needle, producing some blood. Next, she cuts a piece of her own hair and, together with her blood and a handkerchief, she creates a talisman made to ensure love. The man she desires, Antonio, has been Purif's lover for some time, but the girl has been unable to achieve a serious commitment. Furthermore, Antonio has been avoiding the girl, since he had no interest whatsoever in maintaining a relationship with her. Purif, no longer a virgin and belonging to a conservative and deeply religious community, has "no use" as potential wife, so she must ensure Antonio's love (or at least, commitment to marriage). Her only desperate alternative is the practice of black magic.

The film follows Purif descent into madness due to the oppressive nature of her sin within a community that looks suspiciously at any deviation from traditional cultural values, especially those which equal femininity with submission. This closely follows the reality of a religious dogma which historically had produced the oppression of any alternative behaviour. As Pollard explains,

> in the 1950s and 1960s, the Italian courts handed down a series of judgments that declared that since the Constitution had implicitly recognized the principle that Catholicism was the sole religion of the State (…), then the protection of the interests of that religion had priority over the rights of religious minorities.[8]

In *Il Demonio,* Catholicism and the church do not function as embodiments of love and understanding but rather as suffocating institutions that sustain the patriarchal abuse of women. This issue is clearly configured during the film's first sequence. While Purif is piercing her breast, on the background one can notice a painting of a saint hanging on the wall; the effect results in the saint looking directly and intently at the girl with a reproachful gaze. Thus, the director's composition seems to suggest that

8 John Pollard, *Catholicism in Modern Italy: Religion, Society and Politics since 1861* (New York: Routledge, 2008), p. 118.

while Purif is performing black magic, Catholicism, the official religion here symbolized by the painting of the saint, is severely condemning her actions.

Traditional Catholicism's oppressive attitude towards women also shapes the second sequence, in which Purif attends a Christian mass. Rather than finding solace there, she only meets suspicion, rejection and gossips, as the other women within the little chapel avoid her. In this sense, it is interesting to note that, in the first sequence, Purif wears a white, soft dress, while, in the church, she wears severe black. Traditional religion is coded as repressive, misogynistic, a representation of the obscurantism that still survived in Italy during the economic miracle, as a remembrance of the strong hold that Fascism and Catholicism, both in mutual complicity, had had upon the country. Pius XI and the Catholic Church were inclined to view Mussolini's rule as one that would conveniently assist in the reconstruction of the Christian traditional values, seriously weakened by the Liberal Revolution of the preceding century, since many of the policies of the regime, especially its deep hostility to Socialism and Communism, suited accurately the Church's political ideals.

Italian politics in the early 1960s were characterized by reformist trends, which were also extended to the reformation of religious dogma. When Pope Pius XII died in 1958, his successor Angelo Roncalli, John XXIII, knowing as the 'good pope', attempted to liberalize the Catholic Church. John XXIII's Vatican II Council of 1962 sought to establish the Church as a source of spiritual and moral guidance for all citizens regardless of political affiliation. John XXIII brought the end of the universal use of Latin in celebrating the Catholic mass and ended the publication of the *Index* of prohibited books. As Celli and Cottino-Jones explains:

> Changes in Italian society in the 1960s saw a decline in applications to religious orders and in church attendance. Some of the social functions performed the Catholic Church in Italy, such as hospital or elderly care and childhood education, would increasingly be assumed by private organizations or the Italian state.[9]

9 Carlo Celli and Marga Cottino-Jones, *A New Guide to Italian Cinema* (New York: Palgrave Macmillan, 2007), p. 84.

Despite attempts by the Church to promote change, its strongest conservative elements maintained the defense of the traditional values. Especially in Southern little towns, Catholicism still pervaded any and each moment of everyday life. When Antonio gets married, for example, his family performs a ritual to grant him a good marriage and, also, scare away any evil. Within the nuptial bedroom and immediately after the wedding, Antonio's family hides a scythe under the couple's bed as a form of scaring evil away. Also, they stroke the mattress while intoning prayers and cover the bed with an improvised cross made of raisins. Unlike black magic, these rituals do not involve physical pain. While Purif must use her own blood and hair as a form of personal involvement in the performing of magic, Catholicism is more "passive" and distant. Catholic politics of bodily intervention should take place only as punishment. Purif's would be the town's perfect scapegoat for any sexual tensions and frustrations among the villagers, while her body is slowly turned into an object of physic aggression and sexual assault, sometimes committed in the name of Catholicism and, in other situations, with no excuses at all. To steal Purif's rights as a citizen, the first step is to objectify her.

This process takes place through animalization. The troubled woman is increasingly used and abused through acts that transform her into an animal, another living being framed simply as "property" rather than a holder of rights. For example, when Purif is running away from two men chasing her, she finds a precarious hidden spot within a flock of lambs. Symbolically, she is another lamb to be sacrificed. The sacrifice, however, does not take the form of bloodshed but, instead, that of rape. The woman is discovered by the shepherd conducting the flock whom, without any further exchange of words, takes Purif by force, raping her. In the next scene, as if nothing had happened, we see Purif while taking water from a river. It is clear that she did not denounced the violence, which is, implicitly presented by the director as something "normal" (i.e., naturalized) in the context of provincial and rural Italy of the period.

The second rape present in the film also includes a process of animalization. Purif is increasingly confident of her relationship with the demon, to the point that she is convinced of been

possessed by Satan. To save her own soul, Purif place her salvation at the hands of a catholic spiritual healer, who conducts the woman through many rituals of purification to help her getting rid of the devil. The chain of rituals encompasses the entire day. In the secrecy of night, the healer obliges the woman to stand at hands and feet, thus resembling a quadruped. The excuse is to write some symbols in Purif's back, but, instead, the healer rapes her. Here, rape is just another link in a chain of intelligible rituals performed upon the female body. Soon enough, an exorcism is performed upon Purif. In the film's most arresting scene, Purif, at the sight of the cross, start to spider-crawls backwards as Reagan will do ten years later in *The Exorcist*.

It should be noted that Purif's family first reaction to her "possession" is to take her to a spiritual healer rather than a sanctioned priest. As Pollard argues,

> there was, as there had been for centuries, a tension, sometimes even a conflict, between the 'official' religion of the institutional church and forms of 'popular religion', that is, the way in which it was practised by the mass of the largely rural, agrarian population.[10]

In *Il Demonio*, popular practices of religion invade any aspect of life, including harvest time or weeding nights. Purif's body is constantly defiled by the daily practices of religion: Catholicism, both as institution and as popular practice, exerts power upon the girl. Purif is raped by the healer and her body twists painfully during the exorcism as a manifestation of inner disturbances exacerbated by Catholic prejudices. Anyone who does not fit within the Catholic doctrine is considered as a possessed one, a dangerous symptom in need of cure. In turn, witchcraft asks for Purif's blood and pain. Catholicism and obscurantism are traces of the national fascist past and its systems of coercion and rhetoric of virility, and it is especially visible on the tortures and animalization that Purif has to endure. As Barbara Spackman vividly states, rape anthropomorphizes fascism.[11]

10 Pollard, p. 12.
11 Barbara Spackman, *Fascist Virilities: Rhetoric, Ideology, and Social Fantasies in Italy* (London: University of Minnesota Press, 1996), p. 163.

Purif's process of animalization begins early, in the course of an encounter with Antonio. During a fight, he calls her 'cane' (dog) and beast. Furthermore, animals, just like women, are chastised and used by religion. Purif beats with a stick a number of lambs in frustration and, in other scene, kills a cat to use it as a tool for witchcraft. If the girl is constantly beaten (in her bed by her father, in the streets by her neighbors and by Antonio) for her wicked behavior, animals must suffer to be part of Purif's wicked actions. It is possible to establish a relationship between the oppression and chastisement of women and animals within the film. Both are vulnerable groups, claimed as property of those stronger within patriarchy. Purif's ardent desire is to become Antonio's wife and thus, complying with a (hetero)normative role within the community, and because of this desire, animals must suffer. Following this line of thought, animals and women can be understood as "brothers" or "sisters" in their link against an institutionalized "speciesism"[12] that frames them as objects, rather than subjects.

Near the end, Purif is "encaged" within a monastery. There, she will be not freed of forms of physical oppression. To embrace a tree (an element of nature no linked to culture and thus, incapable of generating oppression), Purif has to goes through rows of barbed wire. Purif ends bleeding and with her clothes torn, as a reminiscence of the many situations of rape that she had been going through her whole life. One of the nuns chastises her and prompts Purif to pray as the sole answer to her anxieties. Pray is a passive (i.e., inoffensive) form of defense against social issues. Since Purif seems not that interested in praying, the nun forces the girl, taking her hands, in making the sign of the cross. Through religion, Purif's body is constantly obliged to perform against her will to satisfy the desires of others (community or lustful men) or to fulfill traditional roles as a religious, pious woman.

Even if incarcerated within a monastery, Purif's presence contaminates the village. As the priest explains to Antonio,

12 Lisa Kemmerer, "Introduction", in *Sister Species: Women, Animals, and Social Justice*, ed. by Lisa Kemmerer (Champaign: University of Illinois Press, 2011), pp. 1-44 (p. 17).

Purif's presence is still haunting the town, spoiling the water and the air. The woman's body is excessive in her love and desire, it lack proper boundaries. Thus is must be contained through the punishment exerted by religion. Purif's body, in an ironic and contradictory movement against her own name (Purification), is a dangerous polluting agent if let unbounded. The village population's attempts to control Purif could represent the last requiem for the excessive violence exerted upon women to force them into traditional roles (coercing them into the home), and it could probably be seen as a sign of continuity from the Fascist government of Benito Mussolini's rule to the age of Catholic "triumphalism", roughly, 1945-58.[13]

The film's climax encapsulates the topic of hypocrisy and violence that runs throughout the story. Antonio, fearing a possible supernatural revenge cast by Purif, stabs the girl and kill her. Previously, he makes love to her one more time. Satisfied his desire, he can terminate the threat that the woman represents. If female's desire is threatening, male desire must be satisfied as an act of violence without consequences. Religion, as institution, had helped Antonio in removing Purif, restoring the status quo within the village.

Non si Sevizia un Paperino: the Mezzogiorno Giallo

Lucio Fulci is well known for horror fans for his gore-drenched films such as *Lo Squartatore di New York* (1982). Even so, his works had encompassed many genres within Italian vernacular cinema, through the sixties until the 1980s. *Non si sevizia un paperino* is one of Fulci's *giallos*, and, agreeably, one of his best. The word *giallo* is Italian for "yellow" and is a term given to a series of mystery novels that the Milanese publisher Mondadori began editing in the late 1920s. These paperbacks, often translations of English-language novels, were presented with vibrant yellow covers, to differentiate them from Mondadori's line of romance novels published with bright blue covers. Soon, giallo will work metonymically for any mystery/crime story, been in book format

13 Pollard, p. 108.

or in film.[14] Furthermore, Xavier Mendik frames *Non si sevizia un paperino* within the specific variant that he calls *mezzogiorno giallo*. This subgenre is set in the Italian South or in a rural landscape "to allow for a more extended examination of the perverse and near pagan practices which reside therein".[15]

In *Non si sevizia un paperino*, detectives and journalists from Milan are drafted into the rustic rural locale of Accendura, to apprehend the murderer who has been killing young boys within the little village. Already from the beginning, distinction is given to sexually active women as potential suspects, including sexually alluring Patrizia (Barbara Bouchet), who stands for modernization and, specially, Maciara (Bolkan), whose beliefs in the dark arts and some extreme antisocial attitudes ensure her to "holds a liminal position within community as both insider and outsider".[16] The film opens with the juxtaposition of a natural landscape crossed by a motorway. Already in these first scenes, which play as background for the film's credits, Fulci establishes the dichotomy between modernity and rural landscape. Highways and cars were symbols of modernity and status within the ethos of the economic miracle, uniting Italy as a whole and, at the same time, opening the country to tourism.

Filmed, like *Il Demonio*, in Matera, the town is populated with old wives dressing in severe black. Catholic Church immediately establishes its authority upon the daily life of the village already from the first tunes offered by the soundtrack: the chimes of the bells of the main chapel. The first shot of the interior of the church is a tilted one, reveling thus some symbolical perturbation. Something is not quite right within the community and within the church. If in *Il Demonio* the painting of a saint looking reproachful prefigured the film's tone, here the presence of a skeleton wearing monk garments is the first sign that unites religion and death. There is no joy within the church, but rather a somber climate of decay and secrecy: the praying boys constantly cast furtive looks to each other.

14 Mikel Koven, *La Dolce Morte: Vernacular Cinema and the Italian Giallo Film* (Lanham: Scarecrow Press, 2006), p. 2.
15 Xavier Mendik, "The Return of the Rural Repressed: Italian Horror and the Mezzogiorno Giallo", in *A Companion to the Horror Film*, ed. by Harry Benshoff (Malden, MA: Blackwell, 2014, pp. 410-425 (p. 410).
16 Koven, p. 53.

Like Purif, Maciara's persona gathers a cluster of different religious beliefs and a brief shot unveils these contradictions. After nailing a series of pins deep into wax dolls, Maciara places them upon a table. The image configures a scattered mix of traditional religious images and paganism. The wax dolls lie together with images of saints and of the Mater Dolorosa and catholic crosses. This sequence is important in a twofold way: first, it establishes that Maciara is a practicing Catholic, rather than some sort of Satanist. Secondly, the fact the Maciara have no problem in leaving her wax dolls next to catholic imagery clearly shows that she does not think as problematic, in her religious beliefs, the mixing of paganism and traditional religion. In this sense, Maciara is similar to Purif in her unease mixing of popular magic with catholic dogma. To both women, Catholicism and magic are not mutually excluding spheres. The image also condenses the process of secularization that Italy, by the Seventies, has gone through, in which, for example, assistance to masses were reduced to the half on comparison to prior decades, even if Catholicism was still the main religion.

Italian feminist author Silvia Federici, makes an interesting analysis of the origin of witchcraft, and how prosecution and punishment of witches as a device was instrumental in the origins of capitalist society, especially to ensure domestic reproduction within the working class. Witches were associated with birth control, abortions and infanticide. This control of women upon the female body should be disintegrated in a context in which the new economic development required a growth population.[17]

Mussolini himself denounces the "dangers" of emancipated women and the need for reproductive requirements: "when work is not a direct impediment to reproduction, it is a distraction, foments an independence and resultant physical and moral habits contrary to childbirth".[18] Thus, Mussolini's ideas framed female bodies as nationalistic objects and baby-making machines. As Gigliola Gori argues, the fascist regime intended to relegate women to the home for most of their time with the help of the "catholic Church, which

17 Silvia Federici, *Calibán y la bruja. Mujeres, cuerpo y acumulación originaria* (Madrid: Traficantes de sueños, 2010), p. 255.
18 Cited in Spackman, p. 163.

had always supported female modesty and maternity".[19] Moreover,
the witch is a woman who resists male dominance and reproduction.
 Following this idea, Maciara, as a witch killing children, is a danger
to both, the deeply catholic south and the capitalist north. Maciara
quickly becomes the main suspect of the children's murders.
After been arrested, she confesses her responsibility. But she ends
explaining that the death of the boys was the result of her spells,
rather than from any direct action. The police quickly released her
because they understand that she has no real responsibility, but the
villagers do not share this view. To them, sorcery is a real fact. In
opposition, to the investigators who had come from the (industrial
and modern) north, her responsibility is null. Maciara's murder is
particularly violent and has many interesting elements that should
attentively analyze. Three male villagers bludgeoned her to death.
The place where the murder takes place is a cemetery, a sacred
landscape linked to Catholicism. Like in *Il Demonio*, Catholic religion
is an institution of oppression and death for women. The cemetery,
however, shows signs of neglect such as broken tombstones or
lopsided religious figures. This situation of neglecting refers to the
crisis and loss of weight that Catholic Church was suffering in the
sixties and seventies, against the advance of secularization. The scene
seems to emphasize the idea that this world of belief is in danger of
extinction: the witch dies and the Church is dying. The scene ends
with a long sequence of an agonizing Maciara crawling to the road
hoping to get to the highway, again a sign of modernity. Finally, she
dies on the side of the road as the cars go by, filled with tourists.
 The Catholic Church has a very important role in the film's plot.
The film's real killer is the village priest, Alberto (Marc Porel). He
radically represents how traditional culture is threatened by cultural
changes. In this sense, Patrizia, who embodies modernity[20] with her
open displays of sexuality, is for him a threatening character. There
is a scene that is quite significant for understanding the role played
by Alberto within the village. The journalist Andrea Martelli (Tomas

19 Gigliola Gori, *Italian Fascism and the Female Body: Sport, Submissive Women
 and Strong Mothers* (New York: Routledge, 2004), p. 54.
20 She wears miniskirts in bright colors (in contrast to the discretion of the
 other women of the village) and her apartment is filled with modern
 objects such as lava and tanning lamps, as examples of the arrival of new
 patterns of cultural consumption.

Milian) is talking to the priest about the events that are changing the life of the town. Alberto signals responsible for the crimes the influence of sensationalist media and explains that he is advocating the censuring of some publications that could, according to his opinion, be proven harmful. According to Pollard, the monitoring of the cultural consumption by controlling media was a real concern of the Christian Democrats who ruled Italy since the end of World War II.[21] The film mirrors some paternalistic practices performed by the Church, in the course of and after Benito Mussolini's regime. While Alberto and Andrea talk, Patrizia shows up. Andrea ironically comments that she is more difficult to control than the press, while Patrizia taunts them about the celibacy imposed upon Catholic priests. Here, the emancipated woman of northern Italy threats and mocks the social structure of the village.

Alberto, moved by paternalism, kills the boys. He is concerned about the salvation of the children, whose innocence is at risk because of the alluring sexuality of the modern times' behaviours. In his mind, killing them at an early age means they die as "innocent" human beings. The film's last scene, in which Alberto is at the brink of throwing a girl from a hill, is very telling in this sense. Andrea gets in a fight with the priest and manages to free the girl; but she quickly returns to the priest's arms and kisses him. To Italian villagers, priests, embodying Catholic religion's power, could not hold any evil. Fulci here seems to denounce this diffused attitude of paternalism by the clergy, which under the excuse of protection, employed social control and violence.

Conclusions

Economic, social and cultural changes of the 1950s and 1960s had a massive impact on Catholic belief and practice, not to mention politics. These changes affected religious belief and religious practice through a process of secularization. Both, *Il Demonio* and *Non si Sevizia un Paperino* emerged and are shaped by the cultural context. Moreover, both films give emphasis to the fact that the practice of traditional religion was still powerful,

21 Pollard, p. 136.

especially in the South. "Decline in the influence of the Church and new ideas of women's liberation had a powerful impact on Italian attitudes to the role of women, family structure and sexual behaviour".[22]

Both Purif and Maciara embody these anxieties about new roles and systems of thought within Italy. They choose the practice of witchcraft not as a path to devil worship, but as a way to resist Catholic (and by extension, patriarchal) dogma. The use of alternative religion in both films testifies not only to a critique of the oppression of women by traditional thinking, but also, to the contiguity between Catholicism and the last traces of the fascist dogmas within Italy. The critical stance is not merely towards Catholicism, but more precisely, towards paternalist fascism, which acts upon the citizens and their bodies. The female body was a direct target, since fascism supports traditional values that relegate women into passive roles. The magic performed by Purif and Maciara is ineffective (showing clearly that they are alone against traditionalism), but even so, they are punished because they not only represent, but *they are* alternative subjectivities with marginal roles within the community.

Both, *Il Demonio* and *Non si Sevizia un Paperino* function as sharp critiques of fascism and how it, sometimes through traditional religion, ruled women. This chapter "re-experienced" these genuinely provocative films to consider the ways in which women, who are unable to fulfill social expectations about gender roles, become figures recipient of (male) dread and community violence.

References

Celli, Carlo and Marga Cottino-Jones, *A New Guide to Italian Cinema* (New York: Palgrave Macmillan, 2007).

Chiesi, Antonio, Martinelli, Alberto and Stefanizzi, Sonia, *Recent Social Trends in Italy, 1960-1995* (Québec: McGill-Queen's University Press, 1999).

Cottino-Jones, Marga, *Women, Desire, and Power in Italian Cinema* (New York: Palgrave MacMillan, 2010).

22 Pollard, p. 149.

Craig, Siobhan, *Cinema after Fascism: The Shattered Screen* (New York: Palgrave MacMillan, 2010).

De Grazia, Victoria, *How Fascism Ruled Women: Italy 1922-1945* (Berkeley: University of California Press, 1992).

Federici, Silvia, *Calibán y la Bruja. Mujeres, Cuerpo y Acumulación Originaria*, trad. Verónica Hendel and Leopoldo Sebastián Touza (Madrid: Traficantes de sueños, 2010).

Gori, Gigliola, *Italian Fascism and the Female Body: Sport, Submissive Women and Strong Mothers* (New York: Routledge, 2004).

Kemmerer, Lisa, "Introduction", in *Sister Species: Women, Animals, and Social Justice*, ed. by Lisa Kemmerer (Champaign: University of Illinois Press, 2011).

Koven, Mikel, *La Dolce Morte: Vernacular Cinema and the Italian Giallo Film* (Lanham: Scarecrow Press, 2006).

Lucas, Tim, *Mario Bava: All the Colors of the Dark* (Cincinnati: Video Watchdog, 2007).

Mendik, Xavier, "The Return of the Rural Repressed: Italian Horror and the Mezzogiorno Giallo", in *A Companion to the Horror Film*, ed. by Harry Benshoff (Malden, MA: Blackwell, 2014).

O'Leary, Alan, *Tragedia All'Italiana: Italian Cinema and Italian Terrorisms, 1970-2010* (Bern: Peter Lang, 2011).

Pollard, John, *Catholicism in Modern Italy: Religion, Society and Politics since 1861* (New York: Routledge, 2008).

Sconce, Jeffrey, *Sleaze Artists: Cinema at the Margins of Taste, Style, and Politics* (Duke University Press, 2007).

Sitney, Adams, *Vital Crises in Italian Cinema: Iconography, Stylistics, Politics* (New York: Oxford University Press, 2013).

ANCIENT RITUALS,
MODERN MYTHS

ROBERTO CHIESI

RITUALS IN AN ARCHAIC ITALY
Religion and documentary cinema (1955-1971)

Under the Italian fascist regime, one could not talk and write about the country's *reality* and above all one could not access the images that would represent it. Those images were forbidden because they contradicted that fake appearance imposed by the regime's propaganda through its newsreels and its films (in which sometimes, however, reality stroke back). Among the forbidden images, there were those who could unveil the social and cultural conditions of the South, such as the poverty and extreme destitution in which entire populations lived, or the nature of certain religious cults, where Catholicism often kept mingling with paganism. When movies transgressed the decorous dictates of the regime, as was the case of the short film *Il pianto delle zitelle* (The Cry of the Spinsters, 1939) by Giacomo Pozzi Bellini, they were censored and pulled from theatrical release. In the process of rediscovering the country's reality that characterized the post-war period, during and beyond Neo-realism, some young filmmakers shared the determination to show, document and denounce the phenomena of backwardness existing in the peninsula, mostly in Southern Italy. Official executives of the Christian Democratic Party, the Catholic ruling majority, often tried to prevent or at least hinder the production of protest films about poor living conditions of the South but some filmmakers managed, in one way or another, to shoot those stories and to reveal the troubles and travails. It was a motivation inspired by the same utopia that united many intellectuals and artists of the time in order to change Italy and intervene in the country's internal affairs, denouncing, with the immediacy of the moving images, those conditions of underdevelopment and backwardness that stifled them. In some cases, there was the need to challenge those cultural and religious archaic connotations, which constituted a

repressed component of Italian cultural identity; marginal but no less important for entire populations. It is no coincidence that some of the filmmakers who produced documentaries on these phenomena were originating from those same lands they had abandoned at a young age. For example, Luigi Di Gianni confessed about Lucania:

> It is a region that stayed with me since I was a child. I have a vivid memory of when I went there for the first time with my father (in Pescopagano, my family's hometown); I was nine years old. The landscape struck me as being so unique, profound, with those twisting roads. And above all, the sense of death.[1]

Cecilia Mangini writes:

> I was born in Puglia, near Bari, from a Southern father and a Tuscan mother, I was six years old when we 'emigrated' to Florence. But every September we went back to the country house of my grandparents, it was a two-day trip by car (...). Briefly, all those years I was fully immersed in that 'pre-industrial and pre-national world' loved by Pier Paolo Pasolini, considered with arrogance and pity from my Tuscan relatives and feared by my mother struggling with the ghosts of trachoma, typhus, lice: instead I felt part of that world, I was living in empathy with its people which were able to throw themselves emotionally in all that surrounded them. In a family, as you can understand, messed up by various neuroses, instinctively I curled up in a little true and imagined meridionalism, considering it as an extraordinary defence. At last, I felt something different.[2]

A not dissimilar phenomenon affected also a filmmaker coming from Northern Italy, Gianfranco Mingozzi:

> I was struck by the images of tarantism and its therapeutic and religious madness. Was it my need to go back to childhood, to find

1 Andrea Meneghelli (eds), *Il culto dell'immagine. Conversazione con Luigi Di Gianni*, in *Uomini e spiriti. I documentari di Luigi Di Gianni*, dvd booklet (Bologna: Fondazione Cineteca di Bologna, 2013), p. 8.
2 Mirko Grasso, *Il cinema e il mondo. Conversazione con Cecilia Mangini*, in *Stendalì. Canti e immagini della morte nella Grecia salentina* (Calimera: Edizioni Kurumuny, 2005), pp. 48-49.

again a lost atmosphere, and perhaps regret, for reassuring and familiar rituals? I do not know, certainly there was also this necessity in addition to wanting to find out – in poor, distant and unknown environments – how my "otherness" had developed and established itself in comparison to other abnormal "otherness", studied, analyzed and explained by the scholar Ernesto De Martino.[3]

The basis of some filmmakers' interest was also personal reasons and the need to embark on a journey that was also a comeback to their culture's origins and of their own imagination, whereby irrational elements evoked contradictory reactions: anger and fascination, horror and pity, confusion and the exigency for understanding.

This journey coincided with the unwritten history of popular Italy, and with the history of the underprivileged and humble people, an apparently marginal story that would have remained intact until the years of the economic boom and partly beyond. It is worth noting that the production dates of short documentaries that deal with the Southern forms of religion, are confined, in those crucial years, between the second half of the 1950s and the early 1970s; Italy, which underwent a forced industrialization that damaged and extinguished in few years very old cultural elements, went through a transformation process that brought material wealth as well as serious imbalances and dramatic malfunctions in society, as it would be acknowledged thereafter. In the 1950s, the fundamental impact of the studies by a great writer and anthropologist Ernesto De Martino (1904-1965) on filmmakers such as Michele Gandin, Luigi Di Gianni, Cecilia Mangini and Gianfranco Mingozzi, was especially important for his analysis about preserved archaic rituals in the South and the protective and defensive meaning held by those who believed and practiced them. De Martino also collaborated with these filmmakers but in very different ways. In 1953, together with Gandin, he launched an encyclopaedic project for Filmeco, intervening in eight entries: *Pisticci* (village in Basilicata), *Lamento Funebre* (Funeral lament), and

3 Gianfranco Mingozzi, *Documento filmato*, in Gianfranco Mingozzi, *La Taranta. Il primo documento filmato sul tarantismo* (Rome: ML edizioni, 2001), p. 12.

Costume lucano (Lucanian tradition) all produced by Gandin. In *Lamento Funebre*, for example, the sound was based on recordings made previously by De Martino and the culminating moments of lamentation were shot, for practical reasons, on outdoors locations when, in reality, these rites took place exclusively indoors. The experience with Filmeco, prematurely abridged, left De Martino dissatisfied. He worked then as scientific advisor for *Magia lucana* (Lucanian magic, 1958) directed by Di Gianni and he inspired the project *Stendalì – Suonano ancora* (Stendalì, they are still playing 1959) by Mangini, where however he is not credited; for both films the authors were inspired by De Martino's studies to produce films featuring their own autonomous creative expression and the recourse to technical and aesthetic choices (for example the sound was recorded in a subsequent moment) which implied taking a distance from more orthodox scientific criteria. De Martino had a proactive role in editing *La passione del grano* (The passion of wheat, 1960) o *Il gioco della falce* (The game of the sickle, 1960) by Lino Del Fra, a film about the harvest ceremonies in San Giorgio Lucano; the only case in which he purposely wrote a commentary for a movie was for *La Taranta* (1962), where Mingozzi, while being faithful to De Martino's methods, managed nonetheless to achieve a personal filmic form.

Beyond the heterodox directions taken by the majority of filmmakers quickly labeled as 'De Martino followers', what is fundamental to highlight here is the very strong impulse that the pages of the scholar (which, it is worth noting, was also a great writer) had on the young filmmakers; they worked with the equally legitimate recklessness one would employ in the work of adaptation of a literary text, where the devotion and the interpretation of meaning can also be executed through infidelity and poetic licences.

Luigi Di Gianni: rituals of disquiet

In Southern Italy, religion, with its rituals and contaminations between Catholicism and paganism, is the most revealing element of popular identity and of its different cultural layers that overlapped and were contaminated over the centuries and later

assimilated in very different forms and traditions, with certain recurring elements. Religious worship, in many places across the nation and in particular in the most backward areas of the South, constitutes a dominant phenomenon in the lives of individuals; it influences their affections and passions, their family life and their choices. Religious worship is the epicentre to which they relate every thought and action, the litmus test which determines their fears as much as their aspirations; religion merges every occurrence that affects their lives and it delivers them to a higher power; from this divine authority they fear punishment as much as they expect miracles and protection.

In the films of Luigi Di Gianni, in particular *Il male di San Donato* (The evil of San Donato, 1965), *Il culto delle pietre* (The ritual of the stones, 1967) and *Nascita di un culto* (Birth of a ritual, 1968), the most significant element is the unveiling of the irrational in front of the camera. The author, inspired by Kafka and Gothic cinema, delves into those irrational dimensions with detachment and absorption at the same time. It is a fascination that coexists with the dismay of those who come from a rational culture and feel the need to confront themselves with the *other*; morevoer, there is the necessity to document the archaic-rural condition and the magic-religious-agricultural tradition, which conceal many dark and enigmatic sides. The films of Di Gianni, which should not to be considered as scientific and objective documents, implode this contradictory tension. In *Il Male di San Donato*, the director films a ritual, a festivity in honour of San Donato, the protector of epileptics and the mentally ill; the ritual takes place in Montesano (near Galatina, Salento) and witnesses the whole town pouring into the church to pay homage to the saint. The ritual becomes an opportunity to liberate the atavistic evils, subjugations and anguish which take on pathological forms and manifest themselves as hysterical convulsions where old and young, men and women seem infected by the loss of all inhibitions. The religious tradition related to this ritual – a tribute to the saint – then becomes a theatre where everyone indulges in tarantism in order to release impulses and instincts that one could not control or even name. Di Gianni frames the suffering crowd with overhead shots alternated with close-ups (of elderly women, in particular), finding a balance

between detachment and emotional participation, where one does not preclude the other.

In *Il culto delle pietre*, Di Gianni moves to Raiano, a village in the Marsica region, near Sulmona; according to the legend, in his youth San Venanzio lived for a short period of time in the caves, and his physical presence infused the rocks with miraculous and magic-therapeutic virtues. During the saint's celebration, many faithful people enter those caves and obsessively seek a contact with the rock surfaces, to protect themselves from physical illnesses in the future. Di Gianni emphasizes the fact that the therapeutic rubbing on the stones takes place away from the clamour of the official celebration, in a small chapel outside the town; moreover, the ritual involves the narrow and underground path leading to the caves of San Venanzio. This is therefore one of those cases where religious devotion blends with beliefs dating back to paganism and that originated from the necessity of safety and protection studied for long time by De Martino. An exasperated and fanatical need of protection evidently reveals a deep sense of insecurity, and it is this terror lived by the people, and exorcised by that obsessive rubbing against the stones, to give a dark dramaturgy to the film. Almost forty years later, Di Gianni returned to Raiano, for the documentary *La Madonna in cielo la "matre" in terra* (The Virgin in the sky, the 'mother' on the earth, 2006) and showed how that hallucinating ritual remained still widely common today.

Di Gianni however went even further in showing the forms of superstition and their hybridization with the official religion. In one of his most significant films, *Nascita di un culto*, he tells how the story of an event, condemned by the Catholic Church, took root with irresistible force among the population of a village, Serra d'Arce, near Campagna (Salerno). Giuseppina Gonella, a tomatoes vendor, was the aunt of Alberto, former seminarian who died young because of a tragic accident. The woman claimed to be possessed by the spirit of his nephew every day, in the hour corresponding to that of his death, and following the possession, she seems to gain a charismatic hold on the people of the village and even magical healing powers, which asserts to cure hundreds of people every day. Around Alberto and his aunt, which became his 'intermediary', a cult was born, linked to the traditional one of Saint Antonino, which attracted the inhabitants of all the neighbouring villages;

following these events, a temporary church was erected but never recognized and indeed tacitly condemned by the official Church. Di Gianni films the face and the mimicry of the woman, who has an ordinary appearance, in the phases before and after the alleged possession, when an adoring crowd surrounds her. He shows the metamorphosis that overwhelmed the woman's behaviour, the surreal atmosphere in which her hallucinating sermons occur and the subsequent visits of her devotees. There are many the details in this story which seems illogical but there are also some that belong to the event's commercial logic of exploitation (the photographs-holy pictures sold by the family of Giuseppina and other gadgets and souvenirs, even a record). In this film, Di Gianni illustrates the crowd's feverish need of divine protection and of direct and privileged contact with a superior entity; something that could defend and cure their illnesses and the fear of living reality's threat. An absolute terror which induces them to disobey the official religion, as if its was not sufficient, and were not enough to control their anxiety towards the future, diseases, suffering and death.

In other film projects, the director has investigated the power relations, associated directly to magic and the occult, enacted by those forms of worship; such as the veneration of an exorcist in *La potenza degli spiriti* (The power of the ghosts, 1968) and the magician Margherita in *L'attaccatura* (1971) set between the Forcella neighbourhood in Neaples and the lake of Cuma (Campania region). In the latter film, Di Gianni films closely a woman, originally from Foggia (Apulia), while she meets her customers, convinced that they have been freed from the evil eye; in other situations, she performs black magic on commission, using animals' heads, dolls and a monkey puppet, probably of satanic origin. The monkey puppet is one of those idols recurring in anthropological documentaries, an image that exemplifies the legacy that the Church has not yet succeeded (still in the early 70s) to normalize.

Cecilia Mangini: the pantomime of death

One of the first short films by Cecilia Mangini, *Stendalì – Suonano ancora* (1959), is a remarkable example of anthropological

'reinvention': the rural, funereal lament over the dead is executed by the women of Martano (near Galatina, Lecce) and its staging is based on a text based on Greek-Salento lamentation chants (the wailing of a mother to a son, or of a daughter for her mother, or of a wife for her husband, or of a husband for his wife etc.), written and interwoven by Pier Paolo Pasolini, who already collaborated with Mangini in *Ignoti alla città*. Mangini explains how she developed the idea together with Lino Del Fra, her husband and artistic companion:

> We were absolutely fascinated by De Martino's concept that the magical phenomenon emerges as an obligation for protection against the power of the negative in everyday life: the weeping ritual intrigued us for its three-millennia survival as a radical self-defence. (...) We were longing to narrate about a submerged Italy, its other cultures, its backwardness, its marginalized people, and De Martino had given us that cognitive grid we were urgently looking for. (...) We did not want to produce an ethnographic documentary, but something else.[4]

That 'something else' is the pantomime and the singing rituals performed to defend their loved ones in the afterlife journey: a crying ritual, an 'archaic survival' in an archaic society, as one could describe the deprived areas of South Italy, where "death would be intolerable and meaningless, if its disrupting pain could not be contained by the crude custom of the 'lament' through which the manifestations of despair are, so to speak, stylized".[5] The defence against the ancestral fear of death is entrusted into a funeral lament, configured as the stylization of centuries old gestures and words; a group of women, who have no ties of kinship with the deceased, performs the ritual practices and repeats it upon request, immersing themselves in total emotional absorption.

Mangini sets up a dialectical relationship between the faces and the essential gestures with which the women recite the grief on behalf of the persons affected by the loss; as in an ancient cathartic spectacle, this has also the function to reassure the living that, once dead, they will not be abandoned to themselves. Mangini

4 Mirko Grasso, *Il cinema e il mondo. Conversazione con Cecilia Mangini*, in *Stendalì. Canti e immagini della morte nella Grecia salentina*, op. cit., pp. 49-50.
5 *Ibidem.*

captures the ancient and profound expression of this form of entertainment: at the beginning, the camera finds an opening among the women, isolating a face and the posture of one of them, among the standing ones. Next, framed from above, one can see the waving movement of the hands and the body of an old woman, which is alternated with the figure of another woman and the web of wrinkles in her face; the latter performs the lament with grief, impulsively materialized by her facial expressions. By an even higher angle from the ceiling, we observe the women kneeled down while taking their white handkerchiefs on the corpse in the coffin; this is followed by a reverse shot from the bottom up, tracking in succession their faces and tight handkerchiefs. The ritual becomes a sort of hallucinatory choreography executed with rhythmic and energetic gestures, which also seems to gather a desperate and atavistic energy. The sharp contrast between the young age of the dead man – which has a heavy crucifix on his chest – and the old age of the officiating women is very much affecting. Other gestures characterize the ritual: at a certain moment, a corpulent woman starts pulling her hair, always rhythmically; towards the end, the gestures become more and more spasmodic (women bow down on the coffin and mourn the dead in extreme proximity), accentuated, by contrast, the prostration of relatives standing up in the room. Eventually, the coffin is removed from the room while the women continue their lamentations in front of the empty space.

Maria e i giorni (Maria and the days, 1959), written and directed by Mangini, is dedicated to Maria Limitone, also known as Maria Capriati, matriarch of a farm in the Molise region inherited from his master and lover many years before; in the film, the protection against the evil eye is reified in carved pumpkins with the shape of the head, illuminated with candles. The camera lingers on this sinister object quite insistently, presenting its ubiquity in different spaces, both in interior and exterior spaces. Usually the pumpkin-head is identified with the Anglo-Saxon Halloween festivity; however, in those years each November it made its appearance in the Italian countryside. The object magnetizes the children's attention so that, from an early age, they get used to accept the image of death. The anthropomorphic form (which is repeated in other artefacts, placed near the fireplace), in fact, refers to death anxiety (the flame has a symbolic and apotropaic magic function). A

swarm of anthropomorphic pumpkins is just a way to exorcise death, transforming the image of the skull into a familiar object through a more reassuring form, a sort of domestic *memento mori*. Subsequently, in the film, the director depicts the objects related to everyday life, and therefore to Maria's story: the oil lamp on the bedside table, next to the glasses and the holy picture of Christ, the photographs of her dead relatives with which the woman communicate in solitude in her bedroom before sleeping. Photographs are hung in frames on the walls, where a crucifix is hanged: Mangini shows only the underside of the crucifix, where one can notice an embossed skull without the lower jaw. The camera lingers on other objects, which represent protection and exorcism, such as garlic. In a tracking shot, which shows the room where the farmers are sleeping all together, we notice the flies that rest on the body of a young man asleep and, a few meters away, Maria kneeling in front of a home altar: she is praying in front of an image of the Virgin Mary with Child, between rosaries, photographs, flies and a votive statue of the Virgin, at least fifty centimetres high. Mangini then frames in the foreground the wrinkled face of Maria, emphasizing her bright and stinging eyes and her solitary concentration, as it happens also in the ritual she performs in the stable where she blesses a horse and the goats. Once again, religion is shaped by personal conviction based on individual will and imagination and not according to the official dogma: the animals are sacred and, without reservations, Maria takes the role of the priest in order to protect them through religious practices contaminated by magic.

Gian Vittorio Baldi and Vittorio De Seta: La casa delle vedove *e* Pasqua in Sicilia

An intimate religiosity performed into a modest interior is also present in one of the best short films made by Gian Vittorio Baldi, *La casa delle vedove* (The house of the widows, 1960), which presents the figures and stories of thirteen old widows with no family; after having worked in the janitorial services of aristocratic houses, they live in a rest home owned by their former masters, in Vicolo delle Ceste (in the center of Rome), under the supervision of a prioress. Among the four walls of their rooms, the camera explores the presence of small

altars where votive pictures and yellowed photographs of relatives are stored carefully. The widows spend their existence waiting for death to come and time is filled with a series of small rituals, reducing life to a minimal occurrence (such as leaving home on a fixed schedule, go to mass, etc.). Baldi, however, avoids any rhetoric of pauperism or politically correctness; the little vexations, mutually inflicted among the women, are not omitted in the film, as much as the accusations between each other and other petty revenges which portray their unhappy and impoverished lives. Among the widows, there is also the last survivor (or so it appears) of the Avezzano earthquake (January 13, 1915), whose only consolation is a statuette of the Infant Jesus given to her as a Christmas gift by the nuns: again a reference to the role of consolation portrayed by objects, this time in full complacency of the official Catholic orthodoxy.

In another film, *Il pianto delle zitelle* (1958), Baldi films the pilgrimage to the sanctuary of Vallepietra; the virgins of Vallepietra walks to the shrine on the first Sunday after Pentecost (in 1939, nearly twenty years before, another documentary of the same subject had been film by Giacomo Pozzi Bellini and written by Emilio Cecchi). Unlike its precedent, Baldi employs colour with astonishing beauty while creating strong personal images, with the intention of transforming a ritual into a spectacle of powerful pagan elements. Three years earlier, another notable documentary filmmaker had filmed an archaic ritual of great visual fascination, a sacred representation in Sicily: *Pasqua in Sicilia* (1955) by Vittorio De Seta, originated from the meeting between the director and Vito Pandolfi. The film is based on the assumption that, as stated in the introductory text, "the drama of the death and resurrection of Jesus is celebrated in the small villages of Sicily with representations that may appear naive and superstitious. In reality, they reflect a feeling of heartfelt and immediate participation". In the film we observe the celebrations of Easter in three Sicilian villages. In the first one, in the village of San Fratello (Messina province), the characters impersonating "the Jews", wearing the traditional yellow and red costumes, with silver and gold ornaments, are hidden behind a dark red mask, while crossing the village playing the trumpets. According to the celebration, they embody the evil forces that conspired against Jesus Christ and brought him to death. Evil is therefore depicted in anonymous appearances, faceless, animated by a great

vitality with the gestures and the colours they wear: the seduction of evil is affirmed not only in the bright colours of the clothes, but also in music and De Seta films those figures with brief shots from different angles: front, at a distance, from above, as in a surreal and still profane musical feast. In the village of Delia (Caltanissetta province), instead, the representation of the Passion takes place with the priests condemning Christ and the soldiers flagellating him. The camera shows the crowd filling up the square, the cross carried by Christ who swerves under the weight and fatigue, again alternating the proximity of Christ with the images of the distant crowd. Later, when the character impersonating Jesus falls, the camera moves to the ground, and then rises again to show the fierce dynamics of the soldiers which harass him through a mise-en-scene perfectly punctuated by the movements of the camera. Among several astonishing images, one in particular portrays a priest wearing a headgear with big devilish horns. Once the Golgotha is reached, a statue of Christ is raised on the cross, while a little girl is waving a white handkerchief that simulates the Holy Shroud. The mimesis between the myth of Christ and its representation is totalizing: the sky darkens as if the temple were actually torn apart and we observe the farmers as dark silhouettes against the light, probably mesmerized by the hallucinatory atmosphere of the Sacred Representation.

Finally, in the village of Aidone (Enna province), the Resurrection of Christ is staged; the "Santuna" (the Apostles), papier-mâché busts phisiognomically featuring the saints, are placed on the shoulders of a man and dressed in light blue, purple and red cloths. Alternating frontal images from a distance and shots from ground-level and from above, the "Santuna" reach the Virgin Mary and announce that Her Son has conquered death: they look like giant puppets running through open gates into the crowd, waiting for the resurrection. It is the repetition of a beneficial ritual: Easter as a promised spiritual life after death. Christ resurrected is a statue carried in triumph, the apotheosis of the representation. But it is not the only statue on view; other statues march together with the "Santuna" among the poor houses of the village. The perspective employed by the director, in the final shots, is kept always from the bottom up: the crowd is supine and subjected and dominated by this grand spectacle and with it, the emblematic image of a population crystallized in their myths.

DANIELE RUGO

THE END GOES ON…
The desert, the jam and the last days of Italy

Between the late 1960s and the late 1970s Italian cinema and literature display an increasing preoccupation with what one could call the 'imminence of the end'. The growing awareness of the ongoing collapse of the material conditions, values and hopes that had propelled and sustained the 'Economic Miracle' finds thematic and formal articulation in a number of works that announce, describe or diagnose the closure of a certain understanding of social and political life. By the early 1970s the forces that had driven the Italian boom had spent their momentum and whilst growth started slowing down, the oil crisis of 1973 affected the everyday habits of a large part of the population.[1] The 'Austerity plan' launched on November 22 of that same year by the then prime minister Giorgio Rumor imposed a number of restrictions on energy consumption, including the interdiction to use cars on Sundays, the compulsory closure of bars, theatres and cinemas no later than 11pm, the conclusion of all broadcasting at the same time, a 40% reduction in street lights (lampposts were to be turned off at 9pm), and the closure of shops at 7pm accompanied by the obligation to switch off front signs. The crisis drew the curtains on the promise of endless progress: many companies ceased operating or suspended their activities, forecasts for national growth were revised down and industrial production was downsized, forcing a substantial number of workers to be laid off. The increasing price of oil compelled the government to abandon mechanisms of price control, triggering fear over the widespread increase of the cost of living (with people rushing to supermarkets to stock up sugar, coffee and pasta). From the front pages of national newspapers,

1 For a reading of the causes of the crisis see Timothy Mitchell, *Carbon Democracy: Political Power in the Age of Oil* (London: Verso, 2011).

Rumor alerted the population about the possible implementation of food and oil rationing. The automobile industry (by then almost entirely controlled by Fiat) saw a 25% downsizing.

The crisis had lasting consequences. The GDP, which had grown on average by 5.8% between 1960 and 1969, slowed down to 3% between 1970 and 1979. Italian economy post-1973 was marked by massive inflation accompanied by a reduction of spending, which culminated in enduring stagflation, a predicament that will last until the early 1980s. In addition by the mid of the 1970s the process of delegitimisation of the State (almost inherent in Italian politics) had reached a new peak. The target of this erosion of legitimacy was not simply the State as abstract concept, but more and more and very concretely the power structure (including the delicate system of alliances, concessions and extortions) created and managed by the Democrazia Cristiana (Christian Democrats). The PCI (Italian Communist Party) was increasingly being associated with this system, either explicitly as an accomplice or implicitly due to its inability to provide a real alternative. Whilst the biggest force at the opposition (at the local elections of 1975 the PCI obtained its best electoral result, with 35% of the vote) the PCI was perceived as being complicit with the political-institutional system because of its defence of legal and social order. The State was under attack both in its foundational values and in the ability of the ruling class to govern the country. This deligitimizing discourse was increasingly directed against all political forces, thus challenging their ability to exercise power in line with the democratic-constitutional principles the State was based on. This attitude of contestation of the legitimacy of the governing class presents a double connotation. Luciano Cafagna distinguishes between, on the one hand, a contestation that implicitly accepts the principles that complied with power, but denounces the neglect of these principles on the side of those who exercise this power and a contestation that denies legitimacy to power precisely because based on principles whose validity is rejected in the first place.[2]

2 Luciano Cafagna, 'Legittimazione e delegittimazione nella storia politica italiana', in L. Di Nucci, E. Galli della Loggia (eds.), *Due nazioni. Legittimazione e delegittimazione nella storia dell'Italia contemporanea,* (Bologna: il Mulino, 2003).

This distinction allows one to see a criticism from within the system and a criticism against the system itself.

Aldo Moro's funeral in 1978 offers an occasion to test the degree of the dilapidation of the legitimacy of the State and its representatives. During his captivity by the Brigate Rosse (Red Brigades) Moro had asked in a letter to his wife for State ministers and officials not to be allowed to attend his funeral. The family executed the will of the former Prime Minister and organized a private ceremony for Moro's burial in Torrita Tiburina. The State authorities however did hold a so-called 'official', 'State' funeral on May 13th. Pope Paul VI officiated the Funeral Mass. All State officials attended, whilst Moro's body was absent. That which was meant to be the commemoration of a man of the State killed by the State's enemies became an empty ritual, with the State's authorities as the only protagonists, as if celebrating the funeral of the institutions they were representing. The mass took place in the Archbasilica of St. John Lateran, which, whilst on Italian territory, enjoys extraterritorial status as one of the properties of the Holy See. The State as the organizing motor of collective life, the reference of belonging and identification, was suspended in a void.

It is worth remembering also that the political authorities, military forces and intelligence agencies had proven unable (and according to some unwilling) to stop the long trail of political or mafia killings that by the late 1970s had become part of daily chronicles. Between 1979 and 1980 the Brigate Rosse killed among others Vittorio Bachelet, professor of law at Rome University; Nicola Giancubi, Attorney general and the journalist Walter Tobagi. Around the same time Prima Linea (Front Line) killed Emanuele Tuttobene, cornel of the Carabinieri and his driver and at the University of Milan Guido Galli, judge and professor of criminology. The fascist group Nuclei Armati Rivoluzionari (NAR) killed in Rome the attorney general Mario Amato. In the same period the Sicilian mafia murdered the then governor of Sicily Piersanti Matterella, the captain of the Carabinieri Emanuele Basile, the attorney general Gaetano Costa and the secretary of the Democrazia Cristiana party Vito Lipari. On August the 2nd 1980 at 10.25am 24kg of explosive detonated at Bologna's railway station, killing 85 people and injuring 200. Militants of fascist terrorist

groups will be condemned for carrying out the attack, but those who commissioned the massacre have not been named yet.

Chronicles from the desert

Whilst there are considerable differences in the ways the authors under consideration here approach the political-economic climate briefly reconstructured above, they all seem to express the sense that Italian society is nearing its end. These positions can be defined according to their reference to the political, social and economic reality that forms the conceptual and thematic background of the works. Two analytical poles can be identified: the end understood as the introduction of a completely transfigured reality (Morselli, Ferreri) and the end as a transfiguring reflection on the actual reality (Sciascia, Rosi, Petri). In all these cases the sense of the end announces the reaching of a limit and the inauguration of a completely new beginning. The dominating feature is thus an understanding of the end as annihilation, completion, often expressed allegorically in the form of serial murders, physical destruction, death of the ruling class or survival of one (or two) human beings. There is however a third figuration of the 'end', which understands it not as a limit, but as an irreplaceable and pervasive experience of the world. This understanding reconfigures the other two and shows the anticipation of renewal that underpins their apparent nihilism. The gap between the end as renewal and the third movement invoked here can be expressed as that between the hope of the end (the promise that the end will generate a new beginning beyond itself) and the end of hope. Inasmuch as hope always announces a future possibility, even if the promised future must pass through obliteration and near extinction, the role of the closing passages of this chapter will be to show how Luigi Comencini's film *L'Ingorgo* (The Traffic Jam, 1979) expresses the sense that the end can be seen as a flattening of time, foreclosing the very possibility of futures, promises and hope. If the first scenario is predicated on the possibility of renewing time, of a time after time, the second seems to diagnose a cronophobic compression.

Attentiveness to the theme of the end can be traced already at the beginning of the 1970's in works as different as Leonardo Sciascia's *Il Contesto* (1971) and Guido Morselli's *Dissipation HG* (written in 1973, published posthumous in 1977). Sciascia publishes *Il Contesto. Una Parodia* (Equal Danger) in 1971, but its writing can be traced back to the late 1960s. Sciascia mentions the novel in an article that appeared in *Il Corriere della Sera*:

> The situation in that country was very difficult: at any moment a revolution could have erupted, a revolution that the revolutionaries did not want and the counter-revolutionaries did not expect': this is how begins the novel that Z. (quelque part en Europe) is writing.[3]

The reference to the political situation of the time is clear, but interestingly Sciascia adopts a rigorous strategy of screening through a series of apophasis and paralipsis. As Squillacioti notes the most evident exclusion is Italy itself:

> the textual signs through which the author moves the plot outside of Italy are numerous: in the country there is an Italian embassy (p. 65); *I Promessi Sposi* and Manzoni are mentioned as a 'famous and boring Italian novel' (p. 57) and 'an Italian catholic' (p. 74).[4]

The complex texture of screening techniques ends up emphasising even more the precise description of the Italian political situation of the late 1960s and early 1970s. Sciascia calls this situation one of ideological desertification:

> I began by trying to write a 'noir' novel, the story of a husband unfairly accused of having poisoned his wife, but I ended up writing *Il Contesto*, the chronicle of an ideological and ideal desertification that in Italy was then just beginning.[5]

The idea of desertification already provides a sense of how important the reflection on the end is for Sciascia (a similar

3 Leonardo Sciascia, *Opere: 1971-1983* (Milan: Bompiani, 2003), p. 613.
4 Paolo Squillacioti, 'Un paese dove tutti hanno strani nomi. Luoghi e personaggi nel Contesto di Sciascia', *Il Nome del testo*, 14, 2012, p. 340.
5 Leonardo Sciascia, *La Sicilia come Metafora: intervista di Marcelle Padovani*. (Milan: Arnoldo Mondadori, 1979), p. 82.

reflection, radicalized, will be at the centre of *Todo Modo*). The theme is developed in the series of unexplained murders investigated by detective Rogas and in the final double killing. The end is seen as nigh and it is understood in terms of physical elimination of the ruling class and its opposition, but also of those forces that Rogas represents. The thought of the end infects the detective as well, who ruminating alone in his flat places the end beyond any lived moment and, as a consequence, beyond time. Sciascia reports Rogas' thoughts as follows:

> He was alone in the house; his wife and children were at the shore. Always alone in the difficult moments of his life. Which difficult moments? He searched for some that resembled the one he was living through now. But this was not a moment; it was the end.[6]

In his adaptation of the novel Francesco Rosi moves the action back to Italy and emphasises more decisively the morbid sense of death that is only implicit in Sciascia's text, composing what a commentator calls a 'funeral dirge'.[7] *Cadaveri Eccellenti* (Exquisite Corpses, 1976) makes use of a number of different locations in order to create a space that is as heterogeneous as unmistakeably Italian. Pasqualino De Santis' photography lends the film an eerie and yet extremely luminous quality, whilst Piero Piccioni's soundtrack bathes the film in a sinister ambiguity. The film opens in a catacomb, where the old judge Varga (played by Charles Vanel) contemplates the mummies just before being assassinated. In the following scene the detective Rogas learns from a capuchin monk (Enrico Ragusa) that Varga visited the catacombs every day, 'in order to learn from the dead the secrets of the living'.

In the same year Elio Petri adapts *Todo Modo* (1976), a work where the sense of annihilation pervades every frame. A plague is decimating the country and in the state of emergency a group of politicians from the ruling party seeks refuge in a hotel run by a priest, Don Gaetano (Marcello Mastroianni). The grandees begin to die one by one in mysterious circumstances, but "Petri

6 Leonardo Sciascia, *The Day of the Owl / Equal Danger*, trans. A. Colquhoun, Manchester: Carcanet, 1988), p. 109.
7 John J. Michalczyk, 'The Political Adaptation: Rosi and Petri Film Sciascia', *Annali d'Italianistica*, 6, 1988, p. 223.

does not reveal the killer(s), leaving the enigma to eat itself, Petri presents the Christian Democracy as a power without power itself the plague. At the end of the film everyone is dead, the ruling class has completed its process of self-destruction, whilst the plague keeps raging in the country.

Two very different authors, the writer Guido Morselli and the filmmaker Marco Ferreri present a less explicitly political and more subtly disguised reflection on the end. Morselli writes *Dissipatio H.G.* in 1972, one year before committing suicide. The novel, as most of Morselli's other works, is initially rejected and will only be published posthumous in 1977. In the book Morselli imagines that humankind (the H.G. of the title stands for 'humani generis') has been wiped out just moments before the protagonist decides to abort – for the time being – his suicide attempt. Whilst all human beings have vanished, the presence of animals and objects becomes more and more prominent. The protagonist develops a strong relationship with everyday objects (and with a gun in particular, who he renames 'the blackeyed lady'), but he is equally possessed by an existential panic as he ponders about his own, inevitably solitary, future. The reversal operated in the novel is particularly revealing: the living have vanished, whilst the one who was determined to bring his life to an end has survived. An individual crisis has been bargained for the apocalypse of the species. In the novel Morselli mentions that the title comes from a Neo-Platonist text by Iamblichus. In the text, which explicitly discusses the end of humankind, the word 'dissipatio' is to be understood not in a moral sense, but as 'evaporation' o 'nebulization'. Morselli refers then to a text by Salvian, a Christian writer from the III century, whom

> caught by evangelical piety for humanity's suffering, hoped for a general 'sublimatio' [...] which consisted in an ascension to the sky after the body of the living had been rendered ethereal through a unique and portentous event. A sudden and unexpected event.[8]

Marco Ferreri confronts the question of the end thematically at least in two films, *Dillinger è morto* (Dillinger is Dead, 1969) and

8 Guido Morselli, *Dissipatio H.G.* (Milan: Adelphi, 1985), pp. 81-82.

Il Seme dell'Uomo (The Seed of Man, 1968). However Ferreri's cinema in general can be seen to work according to a process of exhaustion. In order for this exhaustion to succeed, Ferreri structures his films around the proximity of two moments: a series of negative possibilities, a power of negation, makes room for a sequence of undefined consequences. What is available to the camera, what the camera can find in the world offers itself only as its own negation. Because for Ferreri 'what is' has always already imploded, it is simply its own ruin; one must film and expose this internal decomposition, that somehow hides itself. The second moment extracts from this multiple negations the opportunity for an affirmation, but here beyond the meanings of this world. It is a possibility whose appraisal can be announced and figured, but whose opacity remains untouched. This affirmation remains impossible to grasp, its grammar yet to be found, it is merely evocative of what could be. There is in Ferreri no guarantee that the image will describe the world or even that the world would appear in the image in ways that can be deciphered. The image announces the possibility for the world to start making sense, again and again, but does not deploy the structure of this sense.

In this sense Ferreri can be called – rather than an apocalyptic filmmaker – a historian of the end of the world. He announces extinction in the midst of the world by showing that everything has already exhausted its force. Extinction is portrayed not with the terms and tones proper of a prophecy, but with the analytical distance proper of a historiography. In Ferreri's films the end has already happened and now the world finds itself in the suspension and inauguration this end has produced. This history of the future produces an outline, the world is re-organizing its sense and nobody can tell whether we will still be capable of understanding it with the same tools we have used so far. Ferreri's monuments punctuate any positivism with reminders of regression and expose sense to all that is spurious. What is monumental about them is the gathering at once of an oversaturation of meaning and the inwardness and exhaustion of the very possibility of meaning. Monuments are to be found in all of Ferreri's films: the body of King Kong in *Ciao Maschio* (Bye Bye Monkey, 1978), the garden of carcasses in La *Grande Bouffe* (Blow-out, 1973), the giant tree travelling across the high-rise blocks of Palermo in *Il Futuro è*

donna (The Future is Woman, 1984) and the city of Sabaudia in *Storia di Piera* (The Story of Piera, 1983). It is, though, the museum in *Il Seme dell'Uomo* that presents the most interesting case. The domestic display assembled by Cino does not just enclose specific objects, it becomes a monument itself. The very ideas sustaining the museum are made part of a history. Ferreri seems to explore a paradox: on the one hand, the museum presents us with sense as accumulation of knowledge and on the other it forecloses sense's singular beginning, its future advent.

At the heart of a museum is a collection, namely, the interruption operated by an organizing principle. At the heart of this principle, though, lies the 'irrational' dispersion of objects in the world. This disorder never stops animating the principle itself. The museum translates dispersion into a concentration that never stops exposing itself to its original disorder. The museum's claim for completeness – redeployment of appearance according to an organizing principle – incorporates the very disorder it claims to overcome. This aporia reveals a series of problems that could lead the museum to the very point of exhaustion. To put it in other words what is at stake is the impossibility for the museum not to depend on the very interruption it exercises. However the most poignant articulation of this sense of the end as behind us appears in *Dillinger is Dead*. Through a meaningless activism, Glauco reduces the world and its order to zero. He follows the logic of multi-tasking literally: nothing has been done, while at the same time there is nothing left to do. At the end of his trajectory, Glauco has exhausted every possibility; he is out of the world. At the same time, his being outside the world is not a departure; it rather means to feel the world according to its opening. Glauco is without sense; he is the man for whom sense has come to an end, but also the one for whom the sense of the world starts all over again. At the end of the film, Glauco leaves his house by car, dives into the sea and swims to a boat. Here he finds a job as a chef and learns that the boat is travelling to Tahiti. The boat travelling towards a red sun before the frame freezes, an essential image whose meaning can be sought only in vain, announces the form of this again.

Comencini: the end again and again

Luigi Comencini, a director capable of moving from bawdy comedies to scorching social critique, forges in his later films a partial reinvention of the theme of the end. Here the catastrophe embraces the everyday, the common man, so that the political disintegration that others see in the (dis)organization and (mal)functioning of the State is seen to permeate the most minute elements of our daily routines. The three films that compose what Gosetti calls 'the farce trilogy'[9] – *Lo Scopone Scientifico* (The Scientific Cardplayer, 1972), *Il Gatto* (The Cat, 1977) and *L'Ingorgo* (The Traffic Jam, 1979) express in varying degrees an intrinsic cruelty that characters both inflict and receive. From the eternally defeated Peppino (Alberto Sordi) to the Old Lady (Bette Davis) whose magnanimity is simply the countersignature of her invincibility; from the greedy Amedeo (Ugo Tognazzi) to the seductive Wanda (Dalila Di Lazzaro); from the languid but predatory actor Montefoschi (Marcello Mastroianni) to the 'socialist' entrepreneur De Benedetti, each character does enough to warrant the audience's affection and yet immediately demonstrates how misplaced this affection was. These films also constitute perhaps the most accomplished demonstration of the end of the *commedia all'Italiana* (comedy Italian style) inasmuch as the reality they depict does not warrant the complicity and bonhomie that functioned as the ground of the *commedia. L'Ingorgo*, like Godard's *Weekend* (1967) loosely based on Julio Cortazar's *La autopista del sur* (The Southern Thruway, 1966), brings these elements to a full development. Unravelling on a traffic jam on the Via Appia Nuova by the Grande Raccordo Anulare the film mobilizes a coral structure anchored to the episode-film reminiscent of Comencini's earlier works (*Tre Notti d'Amore* (Three Nights of Love, 1964), *Quelle Strane Occasioni* (Strange Ocassion, 1976), *Basta che non si sappia in giro* (As long as nobody knows, 1976)). As Jean Gili writes the film "is made possible by the accumulation of experiences and points of view" and "reaches the spectator through the stylistic choice of the apologue".[10] Comencini introduces a diverse mixture of characters played by

9 Giorgio Gosetti, *Luigi Comencini* (Florence: Il Castoro, 1988) p. 57.
10 Jean Gili, *Luigi Comencini* (Rome: Gramese Editore, 2005), p. 91.

a stellar cast (including Alberto Sordi, Marcello Mastroianni, Ugo Tognazzi, Fernando Rey, Annie Girardot, Angela Molina, Gerard Depardieu, Stefania Sandrelli, Patrick Dewaere, Harry Baer, Ciccio Ingrassia). The film begins and ends with the traffic jam. Apart from a few instances the drivers do not move their cars and station in or around them engaging in a series of interactions with other travellers. The jam never unravels and offers a rather bleak view of the humanity therein caught. In many ways the metaphor chosen by Comencini for *L'Ingorgo* offers a perfect reversal of Risi's *Il Sorpasso* (The Easy Life, 1962), which more than any other film captured the years of the Boom.

As it is typical of Comencini,[11] despite the apparent mechanical nature of the film where each character symbolically stands for a specific social, economic and cultural construct, the attention is directed not much at the ideological or symbolic element but at the emotional burdens one character places on the other. In this respect *L'Ingorgo* reinforces once more Comencini's coherence, the insistence on the idea of cinema as inspiring feelings, rather than representing ideas. As Gili puts it the film "does not share anything with the academic illustration nor does it evoke at any moment the thesis film".[12] The critique of Italian society respects the traditional scheme and emphasises a number of well-known and widely exploited traits (a widespread lack of civility, ordinary forms of fascism), but whilst in previous Comencini's films one was left somewhere between comedy and tragedy, in *L'Ingorgo* the spirit of critique is almost entirely consumed and leaves room for a bitter despair. If there are elements of denunciation, these do not survive the tide of savagery that flows from the jam. The traffic jam itself, with the mass of cars occupying the highway, expresses the idea that a meaningless agitation has replaced the promise of amelioration, the perspective of perfectibility has been abandoned. The possibilities opened up by the end of World War II and even the productive frictions released by the Economic Miracle have run out of steam, no form of social organization emerges and no attempt is made to understand what is happening.

11 See for instance Jean Gili, 'Luigi Comencini 1916-2007: Les sentiments avant les idées', *Positif*, 557-558, 2007, p. 142.
12 Jean Gili, *Luigi Comencini*, p. 93.

L'Ingorgo reflects this shift in perspective: the sense of ruination dominates the atmosphere of the film, the repeated small atrocities, the disintegration of manners, the food and water shortage, the pestilential fumes that blow on the highway, the dire conditions in which drivers and passengers find themselves places the film in the tradition of the apocalyptic/catastrophic film. The traffic jam as a plague, the helicopter that from time to time hovers over the highway as an uncooperative angel. The entire climate of the film – decisively helped by Fiorenzo Carpi's subtly threatening soundtrack and by Ennio Guarnieri's overcrowded or desolate frames – is apocalyptic and presents the happening of a final disaster. However Comencini rejects the label of 'catastrophe-film', preferring to define the film as one demonstrating "the dominant way in which today we get used to the catastrophe".[13] Comencini reinforces this idea precisely with the arrival of the helicopter at the end of the film. In the script written by the director together with Maccari and Zapponi one reads

> Little by little, wearily, the engines start, a louder and louder rumble rises from the jam. The desperate choir of car horns resounds, but nobody moves. Until the engines are switched off, the horns are still again. The jam slips back into silence. Until when?[14]

As Gili writes, Comencini convinces the audience that the jam is about to untangle and that cars will begin moving forward, "but it is a false hope, the cars don't move, the engines shut up, the silence falls on the crowd momentarily revivified".[15] This sense of the catastrophe as habit is perhaps most exactly expressed by the family travelling on their way to Naples with their son who has spent the last six years in a profound sleep kept alive only by injections. Comencini reverses the sense of the end. We can think with Rosi and Petri of the end as giving way to a new beginning, a discrete event operating as an ultimate limit after which radical change is to be expected. In this sense these works reproduce the teleological argument of the end as ultimate revelation. *L'Ingorgo*

13 Luigi Comencini, *Il cinema secondo me. Scritti e interviste (1974-1992)* (Florence: Il Castoro, 2006), p. 196.
14 Luigi Comencini (1979), *L'Ingorgo* (Bologna: Cappelli Editore, 1979), p. 108.
15 Luigi Comencini, *Il cinema secondo me*, p. 94.

moves in a different direction. As Jean-Luc Nancy reminds us "the denouement of Greek tragedy in the catastrophe led the drama at the same time to its extremity and to its resolution – purification, expulsion, conjuration, abreaction, liberation".[16] The end as catastrophic is always also cathartic; it isalways – as Virilio shows – a potentially redeeming force (2007). It is this sense of a purification that *L'Ingorgo* denies, showing instead that the end, the catastrophe rather than being a discrete event that inaugurates a new beginning is a condition, a profound sleep, a state of survival. Comencini removes from the idea of the end all evental and revelatory connotations. Once seen from this other side the rapturous versions of the end previously analyzed become almost consoling, since it promises to usher in a new beginning. Comencini understands the end as a flattening force rather than one unlocking change. What is threatening is not its sudden irruption, but its ability to swallow everything in its flat persistency, to finally annihilate any project of renewal. The end opens up on the negation of any opening, it does not reveal or renew, quite simply the end goes on and on...

References

Cafagna, Luciano, 'Legittimazione e delegittimazione nella storia politica italiana', in L. Di Nucci, E. Galli della Loggia (eds.), *Due nazioni. Legittimazione e delegittimazione nella storia dell'Italia contemporanea* (Bologna: il Mulino, 2003).

Comencini, Luigi, *L'Ingorgo* (Bologna: Cappelli Editore, 1979).

Comencini, Luigi, *Il cinema secondo me. Scritti e interviste (1974-1992)*, (Florence: Il Castoro, 2006).

Cortazar, Julio, *Todos los fuegos el fuego* (Buenos Aires: Editorial Sudamericana, 1966).

Gili, Jean, *Luigi Comencini* (Rome: Gramese Editore, 2005).

Gili, Jean, 'Luigi Comencini 1916-2007: Les sentiments avant les idées', *Positif*, 557-558, pp. 141-142.

Gosetti, Giorgio, *Luigi Comencini* (Florence: Il Castoro, 1988).

Michalczyk, John J., 'The Political Adaptation: Rosi and Petri Film Sciascia', *Annali d'Italianistica*, 6, 1988, pp. 220-230.

16 Jean-Luc Nancy, *L'Equivalence des catastrophes (Après Fukushima)*, (Paris: Galilée, 2012), p. 20.

Morselli, Guido, *Dissipatio H.G.* (Milan: Adelphi, 1985).

Nancy, Jean-Luc, *L'Equivalence des catastrophes (Après Fukushima)*, (Paris: Galilée, 2012).

Sciascia, Leonardo, *La Sicilia come Metafora: intervista di Marcelle Padovani* (Milan: Arnoldo Mondadori, 1979).

Sciascia, Leonardo, *The Day of the Owl / Equal Danger*, trans. A. Colquhoun, (Manchester: Carcanet, 1988)

Sciascia, Leonardo, *Opere: 1971-1983* (Milan: Bompiani, 2003).

Squillacioti, Paolo, 'Un paese dove tutti hanno strani nomi. Luoghi e personaggi nel Contesto di Sciascia', *Il Nome del testo*, 14, 2012, pp. 339-348.

Virilio, P. (2007), *The Original Accident*, trans. J.Rose, Cambridge: Polity.

Traffic Jam, Luigi Comencini, 1979

NOTES ON CONTRIBUTORS

Roberto Cavallini is Assistant Professor in the Radio, TV and Cinema Department, Faculty of Communication at Yasar University, Izmir (Turkey). After studying Art History and Aesthetics at Cà Foscari University of Venice, Roberto was awarded a PhD in Visual Culture in 2010 from Goldsmiths, University of London. His research interests include Italian and European Cinema, documentary cinema and the essay film, World Cinema and visual cultures. His publications include a book chapter on the work of Pier Paolo Pasolini (Scarecrow Press), and several articles which appeared in journals including Aniki – Portuguese Journal of the Moving Image, Cinema & Storia, Lo Squaderno – Explorations in Space and Society. He is part of the editorial board of 'Italian Frame', a new book series published by Mimesis International.

Roberto Chiesi is a film critic and director of the Centro Studi – Archivio Pasolini at the Cineteca in Bologna; he contributed to the volumes of *Dizionario Treccani del cinema* and to *Storia del cinema italiano 1970-1975*, published by Scuola Nazionale di Cinema. He is author and curator of the following volumes: *Hou Hsiao-hsien* (2002), *Jean-Luc Godard*, (2003), *Pasolini, Callas e «Medea»* (2007), *Il cinema noir francese* (2015), *Cristo mi chiama ma senza luce* (2015). For the Cineteca of Bologna editions, he is the author of *La rabbia* (2008), *Appunti per un'Orestiade africana* (2009, dvd and book), *Fuoco! Il cinema di Gian Vittorio Baldi* (2009), *L'Oriente di Pasolini* (2011), *Accattone* (2015), *Il mio cinema* (2015) by Pier Paolo Pasolini and the dvd edition of *Salò o le 120 giornate di Sodoma by Pier Paolo Pasolini* (2015).

Silvia Dibeltulo is a researcher and associate lecturer at Oxford Brookes University, where she is currently working on the AHRC-funded *Italian Cinema Audiences project*, and teaching film genre and film history. She obtained her PhD in Film Studies from Trinity College Dublin with a dissertation on cinematic representations of Irish-Americans and Italian-Americans in Hollywood gangster film. Her research mainly focuses on the representation of identity on screen, specifically in terms of ethnicity, nationality, gender and culture. Her work also centers on film genre theory and history, audience and reception studies, film censorship, cinema heritage, and digital humanities. Her publications include the article 'Family, Gang and Ethnicity in Italian-themed Hollywood Gangster Films', which appeared recently in *Film International* (2015) and the book chapter 'Old and New Irish Ethnics: Exploring ethnic and gender representation in P.S. I Love You' (in *Ireland and Cinema: Culture and Contexts*, Palgrave Macmillan, 2015).

Juan Juvè graduated at the Universidad de Buenos Aires (UBA) – Facultad de Ciencias Sociales. He is a lecturer in sociology, horror cinema and popular culture. He has published in journals such as *Lindes* and a book chapter in *Science Fiction and the Abolition of Man*, edited by Mark J. Boone and Kevin C. Neece (Wipf and Stock, 2016).

Fernando Pagnoni currently works at Universidad de Buenos Aires (UBA) – Facultad de Filosofía y Letras (Argentina)-, as Graduate Teaching Assistant of "Literatura de las Artes Combinadas II." He teaches seminars on American Horror Cinema and Euro Horror. He is director of the research group on horror cinema "Grite" and has published articles on Argentinian and international cinema and drama in the following publications: *Imagofagia, Stichomythia, Anagnórisis, Lindes* and *UpStage Journal* among others. He has published articles in the books *Undead in the West*, edited by Cynthia Miller, *To See the Saw Movies: Essays on Torture Porn and Post 9/11 Horror*, edited by John Wallis, *The Culture and Philosophy of Ridley Scott*, edited by Adam Barkman, *The Cinema of the Swimming Pool*, edited by Pam Hirsch, *Dreamscapes in Italian Cinema*, edited by Francesco Pascuzzi, among others.

Laura Rascaroli is Professor of Film and Screen Media at University College Cork, Ireland. Her interests span art film, modernism and postmodernism, geopolitics, nonfiction, the essay film, and first-person cinema, often in relation to issues of social, political, intellectual, and artistic European history. She is the author and editor of several volumes, including *The Personal Camera: Subjective Cinema and the Essay Film* (2009), *Crossing New Europe: Postmodern Travel and the European Road Movie* (2006), co-written with Ewa Mazierska, and *Antonioni: Centenary Essays* (2011), co-edited with John David Rhodes. She is general editor of *Alphaville: Journal of Film and Screen Media.*

Daniele Rugo is Lecturer in Film at Brunel University London. His research intersects philosophy, world cinema and documentary. He is the recipient of an AHRC Innovation Grant for the project Following The Wires, which uses film to examine post-conflict scenarios in Lebanon. He is the author of two books: *Philosophy and the Patience of Film* (2016) and *Jean-Luc Nancy and the Thinking of Otherness* (2013) and his articles have appeared in various journals including Angelaki, Cultural Politics, Film-Philosophy, Asian Cinema, Journal of Italian Cinema. He's currently editing (with Nikolaj Lübecker) a volume on the work of James Benning for Edinburgh University Press.

Tomaso Subini is Researcher at the University of Milan, Italy. His research has developed along three directions: 1) the reconstruction of the relationship between the Catholic Church and the cinema between the '40s and the '70s; 2) the analysis of religious movies; 3) the study of catholic film criticism. These lines of investigation have converged in three books, which are characterized by the effort to create a synthesis between the historical and philological method (i.e. archive research and reconstruction of the film) and the critical and theoretical method (i.e. analysis of the film). He is currently Principal Investigator of the PRIN (Scientific research program of relevant national interest) project "The role of Italian cinema in the negotiating processes of religious and social conflicts between 1945 and the Sixties".

Daniela Treveri Gennari is Reader in Film Studies at Oxford Brookes University. She works on post-war popular cinema and her particular interests are audiences, film exhibition and programming, as well as issues of censorship, Catholic influence on cinema history in general and more specifically on the development of Italian film industry between 1945 and 1960. Daniela is currently leading a major AHRC funded project, *In search of Italian cinema audiences in the 1940s and 1950s: Gender, Genre and National Identity* in collaboration with the Universities of Bristol and Exeter. Moreover, she is leading the British Academy/Leverhulme funded *Mapping European Cinema: A Comparative Project on Cinema-Going Experiences in the 1950s* in collaboration with the Universities of Ghent (Belgium) and Leicester (UK). Daniela's research has been published in several academic journals (such as the *Historical Journal of Film, Radio and Television,* and *Film History*) and in selected edited volumes.

Fabio Vighi teaches at Cardiff University, UK. His recent publications include *Critical Theory and the Crisis of Contemporary Capitalism* (2015 – co-authored with Heiko Feldner), *States of Crises and Post-Capitalist Scenarios* (2014, co-edited with Heiko Feldner and Slavoj Zizek), *Critical Theory and Film: Re-thinking Ideology through Film Noir* (2012), *On Zizek's Dialectics: Surplus, Subtraction, Sublimation* (2010), *Sexual Difference in European Cinema* (2009).

Printed by Booksfactory – Szczecin (Poland) in November 2016